THE
1959
YELLOWSTONE
EARTHQUAKE

THE
1959
YELLOWSTONE
EARTHQUAKE

LARRY MORRIS

FOREWORD BY LEE WHITTLESEY
YELLOWSTONE NATIONAL PARK HISTORIAN

THE
History
PRESS

Published by The History Press
Charleston, SC
www.historypress.net

Copyright © 2016 by Larry E. Morris
All rights reserved

Front cover: Courtesy of U.S. Forest Service.
Back cover: Courtesy of Gallatin History Museum, Bozeman, Montana; *inset*: Courtesy of
John Owen.

First published 2016

Manufactured in the United States

ISBN 978.1.46711.996.2

Library of Congress Control Number: 2016933547

I taught fifth and sixth grades for nine years and third and fourth grades for six years. I enjoyed the youngsters and loved reading good literature to them. We often laughed and cried together over stories. I'll never forget reading Where the Red Fern Grows *by Wilson Rawls. It's a story of a boy and his dogs. The children loved it and begged each day for one more chapter.*
—*Irene Bennet Dunn,* Out of the Night

This book is dedicated to the memory of Ernest Bruffey, the twenty-ninth victim of the 1959 Yellowstone earthquake.

CONTENTS

FOREWORD

In Yellowstone National Park, Wyoming-Montana-Idaho, where I have lived and worked for more than thirty-five years, the 1959 earthquake is still remembered and revered by park employees and many visitors as a major event in both cultural history and natural history. With its epicenter on Grayling Creek just inside the northwest boundary of the park, "the 7.5 quake—still the largest ever recorded in the Rocky Mountains—struck at 11:37 p.m. and sent eighty million tons of rock thundering down on a campground filled with…men, women, and children."

We have long possessed scattered sources on it that ranged from the brief booklet by Edmund Christopherson entitled *The Night the Mountain Fell* (1960) to the very technical book by Smith and Siegel entitled *Windows into the Earth* (2000). But until now, there was no book that fell between those two categories because even Doug Huigen's book *Cataclysm* concentrated more on the technical aspects of the quake than on the human stories. With the publication of Larry Morris's *The 1959 Yellowstone Earthquake*, we now have a useful, non-technical history of this episode, including the parts that are "rich with human drama."

On the earth as a whole, the strongest recorded earthquake was, for many years in the twentieth century, an 8.5 quake recorded in Alaska in 1964 (although that quake was eventually recalculated to 9.2). In recent years, two earthquakes have dwarfed it, at least in fatalities: the Tohoku quake in Japan in 2011, which was recorded at 9.0 and killed around 18,200 people, and the Indian Ocean Earthquake in Indonesia in 2004 that was

recorded at 9.1 and killed around 280,000 people. But through history, quakes not nearly as strong as these two killed far more people. For example, the deadliest earthquake in history for fatalities occurred in 1556 in Shaanxi, China, when 830,000 people died, and it has been estimated to have been only 8.2 to 8.3 in magnitude.

Earthquakes that occur in cities or tourism-based areas always present the possibility that unrecorded visitors might be killed there without anyone immediately knowing of it, especially when, as in Yellowstone in 1959, those visitors were buried under tons of rock. That situation can add complexity to an already overwhelming tragedy, and such was the case in Yellowstone. By five days after the quake, the Red Cross had compiled a list of about 1,500 people who "might have been in the area when the quake hit." Instead, 28 people died (19 bodies were never recovered), and all of their stories—many told here—were wrenching and dramatic.

Yellowstone receives hundreds of small earthquakes per year, and interpreters and geyser-gazers today still discuss the great changes that the '59 quake imprinted onto the park's geysers and hot springs. Historians and history buffs still examine with interest old photographs of rock slides, cracked roads and submerged houses, and Old Faithful Inn tour guides still orate about the earthquake damage to that famous building.

The 1959 earthquake was a major, historic event in the Greater Yellowstone Ecosystem because in addition to Yellowstone National Park, it affected southern Montana, western Idaho and parts of northwestern Wyoming that were not inside the world's first national park.

I invite you now to join Larry Morris and The History Press in their high-adventure chronicling of human drama in the northern Rocky Mountains—namely, the 1959 Yellowstone earthquake.

<div align="right">

Lee H. Whittlesey
Yellowstone National Park Historian
National Park Service
Author of *Death in Yellowstone: Accidents and
Foolhardiness in the First National Park* (2014)

</div>

ACKNOWLEDGEMENTS

A quarter century ago, Carole Painter, the first person I interviewed about the 1959 Yellowstone earthquake, was very gracious in meeting with me and answering my questions. My association with the Painter family came full circle during the last year, when Carole's sister Anita Painter Thon, the author of two excellent books about the disaster, helped me on several occasions. My heartfelt thanks to both of them.

I owe a similar debt of gratitude to two others who also lost family members in the earthquake: Martin Stryker and Terry Stowe. I consider it an honor to help preserve the memory of their loved ones.

It was a privilege to talk with Glen Stevens, who passed away in 1999, nine years before his death. I appreciate his friendliness and helpfulness.

I was born in Idaho Falls, a stone's throw from the Snake River, and grew up there. The earthquake area was two hours away, and not long after the site was opened to the public in 1960, my parents, Gene and Velma Morris; my sister, Lorraine; my brother, Kent; and I toured the Madison River Canyon. That experience, especially seeing the names on the plaque, made a powerful and permanent impression on me, and in the 1980s, my wife, Deborah, and I took our children—Isaac, Courtney, Justin and Whitney—to see Earthquake Lake, the slide and the plaque. I appreciate the support of all these loved ones and the sympathy they have shown for the victims as I have worked on this book over the years.

Thanks to Brian Cannon and his colleagues at the Charles Redd Center for Western Studies, Brigham Young University. The Redd Center funded

research in the great state of Montana. During that and subsequent trips, I was assisted by librarians and archivists at the Mansfield Library Archives and Special Collections, University of Montana, Missoula; the Montana Historical Society, Helena; and the Utah Historical Society, Salt Lake City. Thanks go to all of them. Special thanks go to Rachel Phillips and her associates at the Gallatin History Museum in Bozeman.

Thanks are due to Lee H. Whittlesey, Yellowstone National Park historian and author of *Death in Yellowstone: Accidents and Foolhardiness in the First National Park*, for writing the foreword to this book and to Blake Gulbransen for producing such informative maps.

I appreciate the encouragement of two of my Montana friends, Adam Brooks and Molly Holz.

Thanks go to my former colleagues at the Church History Library of the Church of Jesus Christ of Latter-Day Saints for their encouragement and their scholarship, especially Mark Ashurst-McGee, Jenny Lund, Mark Staker, Eric Smith, Ron Esplin, Joe and Kay Darowski, Rachel Osborne, Constance Lewis, Nate Waite, Kathryn Burnside, Mandy Owens, Linda Hunter Adams, Sharon Nielsen, Gerrit Dirkmaat, Michael MacKay, Bill Slaughter, Michael Landon and Reid Neilson.

I am grateful for the help of Dan Donegan, John Owen and Bill Conley, all of whom were involved—but, fortunately, not injured—in the earthquake. I also received valuable assistance from one of the smokejumpers who parachuted in to help victims, Bob Nicol. My thanks go to him.

Thanks go to Artie Crisp and Julia Turner, my editors at The History Press, who have been great to work with.

Last of all, I am grateful for the help of Joanne Girvin, Visitor Services Information assistant with the Forest Service's Earthquake Lake Visitor Center, and Tootie Greene, the nurse who helped so many injured people that long night after the earthquake. I believe the two of them have done more than anyone else to preserve the incredible story of what happened on August 17, 1959, and during the hours and days afterward.

1

"THE END OF THE WORLD"

I heard a terrible rumble and looked up," air force warrant officer Victor James said. "I saw the whole mountain crumbling. It was awful. I saw a lot of fighting during World War II, but I never heard such a roar."[1]

"The roar sounded like the end of the world," said S.B. Gilstad.[2]

Camping out in Montana's Madison River Canyon, Irene and Purley "Pud" Bennett and their four children had settled in just a few hours earlier, gazing up at a spectacular full moon as they drifted asleep. Now Irene and Pud woke to an "incredible rumbling sound."

"What's happening?" Pud yelled above the chaos.[3] He stood up but was caught in a maelstrom of wind, rocks and water. Grasping a sapling, he tried to hold on. That was the last thing Irene remembered. Searchers later concluded, however, that after she lost consciousness, the gale blew the car past her, ripped the clothes from her body and swept her across the river into a mass of boulders and trees.

As one report summarized:

At 11:37 PM Mountain Time on Monday, August 17, 1959, a magnitude-6.3 foreshock was followed within seconds by a major earthquake of magnitude 7.5. The strong shaking lasted less than a minute. It sent an entire mountainside crashing down at 100 miles per hour on the lower end of Rock Creek Campground. The slide flowed from south to north, falling more than 1,000 feet and...[pushing] winds of nearly hurricane force in front of it. Then the landslide slammed into the

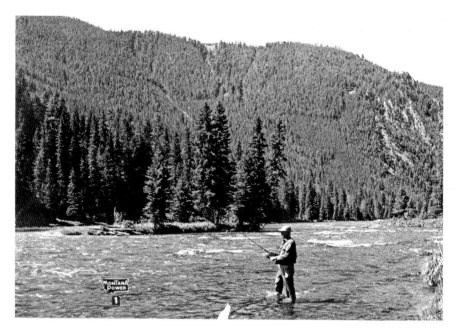

A photo taken near Rock Creek Campground before the earthquake. This stretch of river was obliterated by hundreds of feet of rocks and trees. *Gallatin History Museum, Bozeman, Montana.*

Madison River, slapping the river from its bed and hurling 30-foot waves upstream and downstream.[4]

The Bennett family, camped on the downstream side of the avalanche, had been hit by one of those tsunamis.

When she came to, Irene was naked, face down on the clammy riverbank, pinned under a pine tree that wouldn't budge, shivering from the wet and cold. Her entire body felt bruised and bloody and aching; her lips swollen and sore; her mouth, nose and ears thick with something that felt like sawdust. She tried to shout, but it came out more like a whimper: "Pud, where is everybody?"

Where's my baby Susan? She's only five and needs me to comfort her. Where was Tom, only eleven and scared? Where were her teenagers, Phil and Carole? *Somebody, please answer me.*

She couldn't see or hear anyone at all. Even the sound of the river had stopped. Something had slammed into her lip and gone all the way through. Moving her head one way or the other brought shooting pains in her neck. Evergreen branches were strewn everywhere, and she carefully pulled a few

branches close for the little modesty and warmth they offered. She rested, then dug with her hands to free herself of the crushing tree. She called out for Pud, for Susan, Tom, Phil and Carole but heard nothing. Throbbing pain and bitter cold seemed to combine in waves that throttled her to the core, with each wave draining her of every ounce of strength and endurance. Then would come a wave of minute relief allowing her to dig again. What could have possibly happened? Where was her family?

The moon, so glorious earlier that night, now began to shine through the dust, and Irene prayed for help, reciting a Psalm she had memorized as a teenager:

> *I will lift up mine eyes unto the hills, from whence cometh my help.*
> *My help cometh from the Lord, which made heaven and earth…*
> *The sun shall not smite thee by day, nor the moon by night.*[5]

Irene, thirty-nine, and Pud, forty-three—a truck driver with the Atlas Building Center in Coeur d'Alene, Idaho—had started a two-week vacation with their children three days earlier, reaching Virginia City, Montana, by way of Missoula. "I want to see the bears!" Susan had shouted when asked

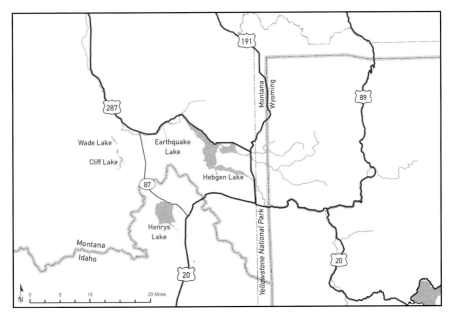

Map 1: The Greater Yellowstone Area. The earthquake's epicenter was near the junction of Highways 287 and 191. *Map by Blake Gulbransen, Lee Library, Brigham Young University.*

15

what she wanted to see on the vacation. Tom said he also wanted to see the animals in Yellowstone Park. The entire family agreed.

As Pud drove southeast through Montana, Susan kept taking off her sandals and putting on her school shoes. "First grade will be fun," she said.

At the Old West town of Virginia City, they saw the house known as Rustlers' Roost; the hotel; the pharmacy, filled with bottles of old-time medicine; the old post office; the dress shop; and the Bale of Hay Saloon. Tom's favorite attraction was the stagecoach ride; Phil's was the grave of Clubfoot George on Boot Hill.

From Virginia City, Pud drove west to Ennis and then south and east to the Madison River Canyon, a popular camping spot just west of Yellowstone Park and near both the Idaho border to the south and the Wyoming border to the east. The developed campsites at Rock Creek Campground were all occupied, but Pud found space in a tranquil meadow a few hundred yards downstream, and the family parked at the end of a row of six or seven other families.

"Making camp late along the Madison River we had an evening snack," Irene wrote. "We spread our tent on the ground, with our sleeping bags on top. It was just a gorgeous night."[6]

The Painter family of Ogden, Utah, had started the day in Yellowstone. Ray, forty-seven, owned a gas station on Washington Boulevard called Ray Painter Service; Myrtle, forty-two, worked full time as the manager of the bakery at an America Food Store. They and their girls—Carole, sixteen, and Anne and Anita, twins who had just turned twelve—were excited to take their first vacation in a twenty-five-foot trailer that featured two bedrooms, a kitchen with a stove and refrigerator and a bathroom with a shower. The family also enjoyed traveling with their dog, a friendly black lab named Princess.

But even before the vacation started, Myrtle had been nervous, feeling premonitions and fretting over the family's safety. She insisted on having the house perfectly clean before they left—in case relatives had to enter the house. She also double checked their insurance coverage. At Yellowstone, the mud pots and the quivering earth set her teeth on edge. "Let's get out of here before the whole place blows up," she had said.

That was fine with Ray; he drove west, out of the park, then north and west along Hebgen Lake and lastly past the dam and down into the canyon, following the Madison River downstream, with the river and towering mountains beyond flashing in and out of view through the trees. At Rock Creek Campground, Ray turned off to the left and wound down

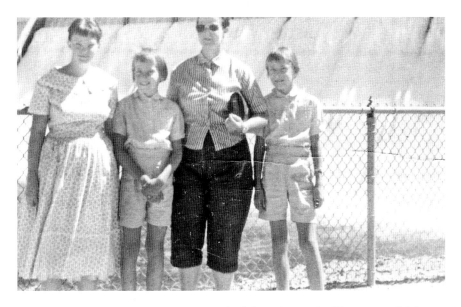

From left to right: Carole, Anne, Myrtle and Anita Painter, late 1950s. *Photo courtesy of Anita Painter Thon.*

a gravel road toward the fast-running river christened by Lewis and Clark and known as a fly-fisherman's paradise. There were thirty-five or forty developed camping spots in the campground, and they were filling up fast. Ray followed the river back upstream and found a nice space. Myrtle and the girls had just started to unpack when Ray decided he wanted more shade and privacy. He drove downstream again and parked near the western edge of the campground.

Several families in the area were already getting acquainted. Next to the Painters was a party of seven people, all relatives or friends of an elderly woman named Holmes who was staying in a trailer with one of her daughters. Also close by in a trailer was a friendly older couple, the Maults. On a ridge between the developed campground and the highway, Ray and Mildred "Tootie" Greene and their nine-year-old son were in a large tent. The two men in the Holmes party, Tony Schreiber and Warren Steele, had been fishing most of the day and showed everyone part of their catch, including a three-pound rainbow trout. Seeing the fish made Ray Painter all the more excited about getting an early start with his rod and reel the next morning.

As the new neighbors were talking, a forest ranger came through the campground warning people about bears. He had hardly left when a bear

Ray and Tootie Greene with their son, Steve, 1959. *Photo courtesy of Tootie Greene.*

wandered into the area and caused quite a stir among Princess and the other dogs. Mildly irritated, especially by a persistent cocker spaniel, the bear climbed several feet up a tree, not leaving until the dogs were all restrained by their owners.

It was a warm night for the mountains. Ray Painter got a good fire going, and he, Myrtle and the girls savored a meal of steak and fried potatoes, waiting until later to roast marshmallows. A huge full moon illuminated the entire campground, as well as the mountain range across the river. The girls and their parents talked and laughed and planned for the next day. Carole chose to sleep in the backseat of the car with Princess. With the huge moon shining brighter than ever, the Painters settled in for a well-deserved night's sleep.

Ninety minutes later, their lives changed forever.

"There was a tremendous roar, absolutely deafening," one witness said years later. "Then it was absolutely stone quiet. You couldn't hear a peep. And then probably within a minute you started to hear cries for help."[7]

The violent shaking and Princess's frantic barking woke Carole in the car. *A bear,* she thought, but that didn't account for the incredible noise. "It

18

sounded like a damn locomotive bearing right down on the car," she said. "Princess was going wild. Everything started to pitch."

A wall of water struck the car, slammed it into a tree and slammed Carole face-first against the car door, leaving her bewildered, vulnerable and hurt. The next instant, cold water rushed inside the car, and she found herself hardly able to move or knowing which way was up. The water kept coming. Mixed with her pain and shock was the sound of Princess's frenzied barking. The car tilted, and the water was suddenly up to her neck. She grabbed a robe, got out of the car and climbed over the trunk to shallow water. As she waded to the shore, she could see several house trailers adrift in the water. "I thought my parents were dead," she said.

The dog was still in the car, barking and barking.

Some campers were calling out for loved ones, others for help. Someone said it had been an earthquake, someone else a flood. Carole wasn't sure what in the world it had been. She wandered the edge of the water, searching for her family. Then she saw a figure slumped against a mass of boulders and trees.

"Carole," said a voice. "I need help—I'm hurt." It was her mom.

Around 11:30 p.m., with Ray and the twins asleep, Myrtle had taken advantage of the quiet to walk out to the river and wash her hair. She had been there just a few minutes when the quake hit, with wind and water slamming her into the rocks. Now she was seriously injured with a collapsed lung and her left arm nearly severed at the elbow.

Carole held her mother's injured arm and helped her up a hill, away from the water. They walked toward a lighted lantern hanging from a tree. A man and woman near the lantern were trying to leave in their car.

"Don't leave," Carole pleaded. "My mother's lost her arm—don't leave us."[8]

"I'm a nurse," said the woman. "Maybe I can help."

It was Tootie Greene. Like many of the others, she and her husband, Ray, and their son, Steve, had arrived the previous evening. Steve had planned on sleeping in his own "room"—at the opposite end of the eighteen-foot tent—but Ray and Tootie had moved him in with them when he didn't feel well. They had barely fallen asleep when they woke to the ground rolling beneath them like an ocean wave and, as Tootie said, "a noise you couldn't believe." Like Carole Painter and many others, Ray compared the roar to a train: "It was like an old steam engine locomotive at full throttle," he said, "only a hundred times louder."

Tootie opened the tent door and saw water, rocks and trees rushing toward them.

"Let's get out of here!" she yelled to Ray.

Most of the tent had collapsed, and Ray could barely make out Steve's head and arm in the tangled canvas. He grabbed Steve and pulled him free, out of the tent. The next thing Tootie knew, they had Steve in the front seat of the station wagon. Ray started the car and tried to drive toward the road, but the same tree that had slammed through the tent had lodged underneath the car and left it immobile. The tree had gone right through the part of the tent where Steve normally slept.

"If he had been there, he'd have been a goner," Tootie later said.

They got out of the car and lit a lantern. Ray also left the car lights on.

"Then people started coming," remembered Tootie.

Someone brought a sleeping bag, helped Myrtle lie down on it and covered her with a blanket. Tootie applied a compress and bandaged Myrtle's arm, reducing but not stopping the flow of blood.

The air was filled with the smell of sulfur. People were crying for help in the darkness, and soon more injured victims began arriving.

"We got busy helping everyone we could," Tootie remembered. "Ray got a foot locker out of the tent, and we clothed ourselves and whoever else we could. The wind and water had knocked the clothes right off people's backs. In many instances, they were not clad at all."

"I used towels and sheets and whatever I could for bandaging," added Tootie, who had recently taken two first-aid classes on a whim. "I knew about shock from my nursing experience, but my first-aid training came in very handy for bandaging these people. The injuries were severe. Many were suffering from shock; there were mangled arms and legs and internal injuries. Everyone was helping—I didn't have to ask for anything but what it wasn't right there."[9]

As Tootie helped Mytle and the others, someone mentioned something about an older couple being trapped in the flood—the Maults.

Grover, seventy-one, and his wife, Lillian, sixty-eight, from Temple City, California, had woken to their trailer rocking back and forth.

"What in the world is that?" exclaimed Grover. "It must be a bear trying to get in the trailer."

"No," shouted Lillian, "it's an earthquake!"

The next thing Grover knew, "everything was upside down." The trailer was knocked end over end and landed right side up in the river. "I got the missus out of the trailer and lifted her on top. She was clad only in her nightie."

Grover fumbled in the dark for some clothes to take up to Lillian but then realized their "home" was sinking. The water was up to his chin by the time

Right: Tootie Greene around the time of her graduation from the Billings Deaconess Hospital School of Nursing, 1950. *Photo courtesy of Tootie Greene.*

Below: An estimated 37 million cubic yards of rock crashed over the river and up the opposite side of the canyon. *National Archives, photo by Leland J. Prater.*

he got out and crawled on top of the trailer. He put on some trousers and a shirt and sweater and wrapped another piece of clothing around Lillian.

"By this time, there was only three or four feet on top of the roof where we could stand. The trailer was sinking fast. I told my wife, 'I pray the Lord we drift toward that tree.'

"We did. I got hold of a branch and the end pulled off. I clutched again, got a better hold."

Grasping Lillian with his right hand, Grover clutched the tree with his left. The trailer disappeared beneath them. "It was horrible. As I tried to pull the missus up, the limbs broke off. I tried to grab higher limbs and clung to the missus with my leg. As we kept on going the limbs kept breaking. Finally, we found one that would hold us."

It seemed unbelievable that just a few hours earlier, the Maults, who had been in the canyon for a week, had enjoyed a Monday night supper with their new friends Clarence and Olive Scott from California and Mary Bair from Georgia, who were all camped nearby in trailers.

"We were amazed at how beautifully the moon shone on the mountains and the river," Grover remembered.

After supper, he and Lillian had taken a long walk down the canyon, visiting with several campers and even picking out a possible spot to build a summer home. They talked for a while after that and then went to bed.

Now, cast into a deluge unimaginable three or four hours earlier, Grover and Lillian tried to hold on to the tree. They were surrounded by water twenty-five or thirty feet deep, and the ghostly lake was rising fast.

"We hollered and hollered," said Grover.

Some people came on foot with ropes but couldn't get close enough to help. They yelled for the Maults to hang on.

The freezing, debris-filled water was up Grover and Lillian's necks. Lillian went under three or four times, the last time gasping for air. "Let me go," she said. "Save yourself."

"If you go, I go, too," he said.[10]

Almost a mile downstream, on the other side of the slide, Irene Bennett continued to dig, to call out for her family and to pray. There was no sign that anyone around her was still alive.

About seven miles west of her, beyond the mouth of the canyon, another family was in trouble.

Near Cliff Lake, fifteen-year-old Martin Stryker had awakened to a "whoosh" of air pressure against the side of the tent. He had been asleep for hours, but his brothers—John, thirteen, and Morgan, eight—were still

The Stryker boys with their dad and stepmom. *From left to right, front*: Martin, Morgan and John; *back*: Edgar H. Stryker and Ethel M. Stryker. *Photo courtesy of Martin Stryker.*

awake, reading comic books by flashlight but apparently oblivious to the noise outside the tent. "I asked them if it was a thunderstorm," Martin wrote decades later, "and they thought it was. I decided to go outside and see what was going on."

Ed and Ethel Stryker, the boys' dad and stepmom, were camped close by in their own tent. For several years, Ed and Ethel had brought the boys, who lived with their mother, Kathryn, from California to Idaho or Montana. "Hunting and fishing were an avocation for Dad, and we took an annual fishing trip during the summer when he had vacation time," wrote Martin. The previous year, they had found great fishing at Cliff Lake and had returned to the same spot this year. Their campsite—with the two tents pitched on a high bank beneath a tree-covered hillside, a picnic table nearby and their boat only thirty or forty yards away, down at the shore of the lake—was perfect.

Martin opened the tent door, stepped out into the night and zipped the door shut behind him. Then he saw the large pine tree that had crashed down onto the car. The tree had blown out the windows, and the family dog, which spent the nights in the car, was nowhere to be seen.

"It then occurred to me that Dad would probably be checking on us, and I turned to the area where their tent was and saw a big boulder on top of it. I walked over and circled the tent to see if there was any sign of life and then I went back inside our tent and carefully put on my clothes without saying anything to my brothers. When I was dressed, I asked them calmly to get up and put on their clothes and make sure their boots were tied."

When John and Morgan were dressed, Martin told them they were in the middle of a huge earthquake and that their dad and Ethel had been killed.

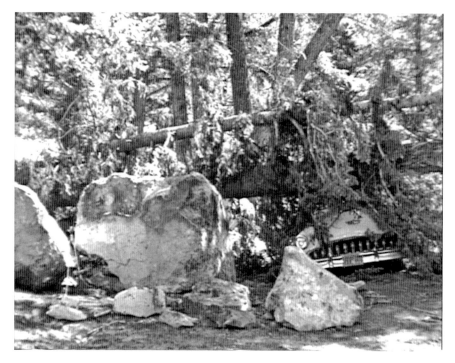

At Cliff Lake, a tree crashed onto the Stryker car, blowing out the windows. *U.S. Forest Service.*

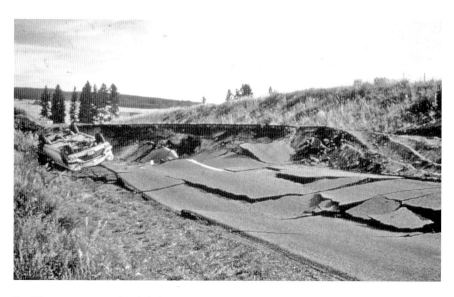

Luckily, no one was seriously injured when the driver of this car, trying to get his family to safety, drove over a six-foot scarp. *U.S. Forest Service.*

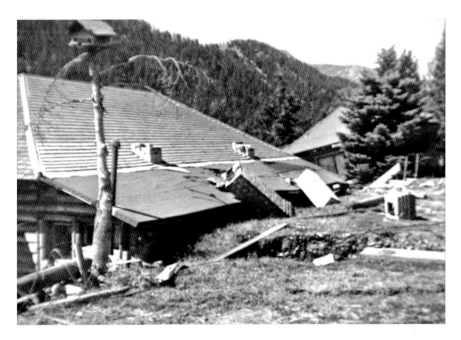

Cabins and homes throughout the area were seriously damaged. *U.S. Forest Service.*

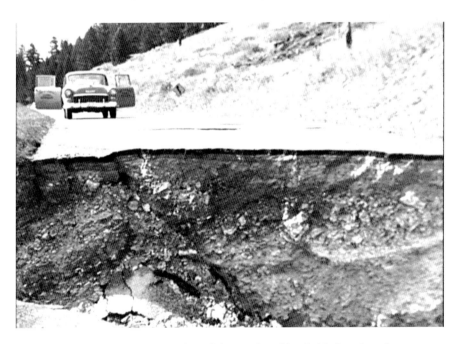

Drivers managing to bypass one section of damaged road inevitably found another damaged section that simply could not be bypassed. *U.S. Forest Service.*

Martin was surprised at his own calmness. "It was a traumatic experience," he wrote, "but I was able to deal with the responsibilities involved due to a loving and supportive upbringing attributable to my mother and from the lessons learned in our church relating to faith and handling stressful situations in life."

There were no other campers nearby, but Martin knew there were people at Wade Lake, about a mile to the north. He, John and Morgan started walking. It had been only six or seven hours since they had driven in from Elko, Nevada, and had excitedly pitched their tents and set up the camp, with "high hopes" for the kind of good fishing they had seen in '58. Now the three of them were leaving alone, without their dad and Ethel, venturing into a setting unimaginable the day before.

"It was loud and dust was blowing up through fissures in the ground," Martin remembered. "We needed our flashlights to navigate the road. There was a smell of pine trees you couldn't believe. Trees four feet in diameter were snapping off like matchsticks."[11]

2
"DOWN IN THE FLOOD"

.

A half hour before the quake, forty-five-year-old Tony Schreiber, a World War II veteran who worked as a mailman in Billings, Montana, had walked out of his trailer to check on the butane tank. The spectacular moon lit up the peaceful campground, where just a few hours earlier, Tony and Warren Steele had shown the neighbors their catch. Warren and his wife, Esther, were just a few yards away in a tent, and Tony's mother-in-law and sister-in-law, Margaret and Verona Holmes, were maybe twenty feet away in their own trailer. Tony looked around the crowded campground for bears but didn't see any. Still, he wanted to be careful, and as he went back inside the trailer, he put a hammer and a flashlight near the dinette he had folded out for his bed. His wife, Germaine, and their daughter, seven-year-old Bonnie, were sleeping in the twin beds.

Tony got ready for bed and lay down. He had barely drifted asleep when he felt the trailer rocking violently. "My wife kept shouting at me, and I was thinking it was a bear around the trailer. I jumped from the bed to the door, opened it and stepped outside, but the trailer was rocking back and forth, and I fell flat on my face. I picked myself up and tried to get back in the trailer. But by that time, I was hit by water and dirt coming from downstream, and I couldn't make my head work."

Looking out the trailer door Tony had left ajar, Germaine saw "a great wall of dirt or whatever it was. I ran to the other end of the trailer to get Bonnie; it was roar, roar all the time—when I got to Bonnie, mud and water hit us. The trailer was tossed sideways, and Bonnie and I were in just a little cubbyhole in the smashed trailer. I called out for Tony."

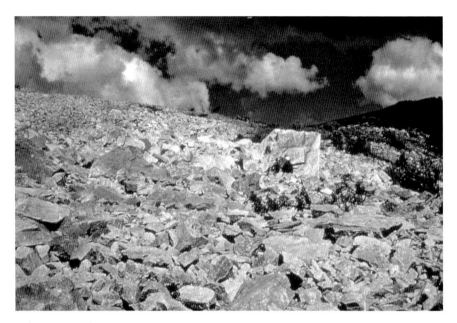

This photo offers a glimpse of the deadly force of the rocks and boulders. Just right of center, three men stand dwarfed by the rectangular-shaped boulder behind them. *U.S. Forest Service.*

Dazed and disoriented, Tony heard Germaine and tried to answer but nearly suffocated in another rush of dirt and water. Then he could suddenly breathe again.

"My head began to get not so cobwebby," he said, "and I knew I had to do something, but everything was crazy and awful all over—people were shouting and everyone was trying to find each other. I saw nothing but rubble and rocks and trees that waved from the top to the very bottom."

Yelling for Germain, he tried again to get back to the trailer, but the water was waist deep. He could see a car under the trees and water. "I finally got back to the trailer, and it was half under water, and I shouted for Bonnie and my wife. My wife said, 'Here she is' and handed Bonnie up. I managed to pull Bonnie through a broken opening—she was bleeding pretty badly and was cut up."

Germaine crawled out through the same broken window, and she and Tony ran for higher ground. "There was a family up there shook up pretty badly, but they done their best to help out," said Tony.

The family lending a helping hand were a middle-aged couple with two teenage boys. Luckily, none of them was hurt, and their trailer was not

damaged; its lights were still working and were a beacon in the dusty darkness. The woman took Bonnie from Germaine and wrapped her in towels. "I'll take care of her," she said. "Go back down and find your people."

Although she was hurt herself, Esther Steele had found Margaret Holmes, severely injured, virtually trapped by a stray car hood. All Esther could see was Margaret's head.

"Verona?" asked Margaret.

"Mrs. Holmes," said Esther, "this is Esther." She freed Margaret but then slipped and fell herself. The two of them sat beside the rising river and prayed. "They thought they were the only ones in the world," Germaine later said.

Also injured, Warren Steele soon found Esther and Margaret. The three of them were struggling toward higher ground when they met Tony and Germaine searching for them.

"They were all beat up," said Tony. "My mother-in-law had no clothes, so I grabbed a blanket from someplace and covered her. 'Oh, my arm, it hurts

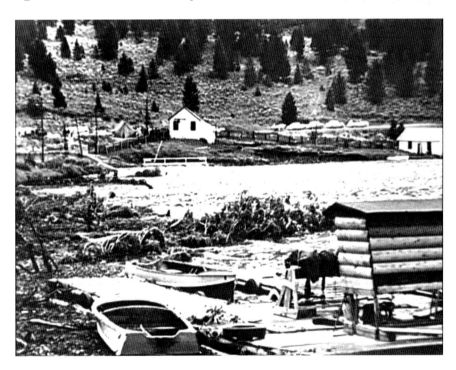

Shorelines of both the river and lake were thick with debris. *U.S. Forest Service.*

29

terrible,' she said. We got her up to that family's trailer. They were parked on high enough ground to escape the water." Six of the seven people in the group were now accounted for.

"Tony and I went back down to look for Verona," said Germaine, "and everything was all smashed. We couldn't recognize our trailer from anything down there."

They called out for Verona and heard her voice but couldn't tell where it was coming from. "I kept shouting her name and she kept answering," said Tony. "I saw a man who was crushed by a tree and his legs were cut up. It was Mr. Armstrong."

Some men were helping Mr. Armstrong, so Tony and Germaine continued the search for Verona and found her in waist-deep water, badly injured. "Rocks, brush, mud and debris caved in around the trailer," Verona later said. "I was swept under water for a long time. One leg became entangled between two logs."

Tony carried Verona up to the trailer. They had barely arrived when someone said they had to get to higher ground because the dam was about to break.

"We started best we could to get everybody across the highway and to higher ground," said Tony, "but my mother-in-law was so badly hurt it was pretty near impossible."

Germaine added, "Mother begged me to leave her. 'Go on, Germaine,' she said. 'Leave me. I can't make it—my feet hurt terribly.'"

"None of us had shoes," Germaine continued. "Mother had a blanket wrapped around her. I kept pulling her with this blanket, and I got her half way up that mountain to where we were going to stop."

Ray Greene approached the trailer and called out: "Is anybody hurt up there?"

"Yes," answered Tony.

"Is it bad?"

"Yes," said Tony.

Ray and some other men came to help. One of them carried Bonnie, and others improvised stretchers from sleeping bags and air mattresses and carried Margaret and Verona to a station wagon.

"I went back up the mountainside where Tony was," said Germaine. "While we were there, you could hear the Maults down in the flood. She was in the water and couldn't get out, and she was yelling and begging for someone to help. They would keep yelling, but we couldn't get down there; the water was too deep. Then there was another man yelling and begging, and that man finally stopped yelling."

Cabins at Halford's Camp (between the dam and the slide) were inundated with water and cast adrift in the new lake. *U.S. Forest Service.*

Tony said that he, Germaine, Bonnie, Warren and Esther—all of whom were injured—were left alone for a time. "There was a group of people way up above who had made a great big fire, but we were in our little group alone waiting for help of some kind. I thought help would never come."

Help did come, however, and it came from Frank Martin, one of several rescuers who seemed to be everywhere that long night. Frank drove his station wagon as close as possible to the Schreibers and Steeles and then shouted out, "For gosh sakes, if there is anyone up there trying to come down, I can get you out!"

"After dragging the injured down the hill, we all piled in Mr. Martin's car," said Tony. "Esther had a rough time of it. We got through the water just in time because it splashed clear up in front of the radiator. We got to higher ground and there were a lot of people there. Some had managed to save some food, and they put it around us as best they could. Mrs. Greene tended our injuries as best she could—all she had to work with was a bottle of aspirin and a lot of courage."[12]

"I WAS AT THE OLD FAITHFUL LODGE [in Yellowstone National Park] with my wife, two children and a neighbor girl," reported John D. Sanders of Salt Lake City. "We were watching a beauty contest with about five hundred people when the quake hit. We all ran outside and headed back to the motel. When we got there we saw people jumping out of windows wearing towels and bathrobes. Water was spurting from broken pipes. We sat in the car all night, and it kept shaking every now and then. It was the most terrifying experience we've ever had. Old Faithful was spouting very hard, and we thought the whole ground around us might blow up any minute."[13]

National Geographic summed up what happened in Yellowstone Park when the quake hit: "The peaks trembled, rockfalls cascaded across roads, and steaming geysers, mud volcanoes, and boiling-hot pools erupted simultaneously in unseen splendor."[14]

Twenty-five miles north of Old Faithful, in the northwest corner of Yellowstone, David Bittner, a nineteen-year-old fire lookout stationed atop 10,666-foot Mount Holmes, had been thrown right out of his bunk by the quake. He grabbed a kerosene lantern, and as he walked outside to the boom of boulders crashing down the mountain and the smell of burned wood, he felt the ground rippling below him.

"It was terrifying," he remembered. "It scrambles your brain."

The moon was bright, and as he looked due west, David could see a wave rolling across Hebgen Lake that looked like a thin, slowly moving pencil line.[15]

In West Yellowstone, a tourist town and the western gateway to Yellowstone Park—almost eight miles south of the earthquake's epicenter—most of the large windows had been shattered. Souvenir shops and grocery stores looked like they had been ransacked, with goods scattered everywhere. Many buildings were severely damaged, including the Union Pacific Depot, a gas station and a school. Power and phone service had both been knocked out.[16]

Warren Russell, a radio ham operating K7ICM from his trailer home, and Hank McTuistan, who had a mobile unit, WA7AYG, in his car, were the first people to reach the outside world from West Yellowstone. At 11:43 p.m., Russell broadcast a description of the quake. "The pavement looked like it was coming toward me in waves a foot high," he said.[17]

Another amateur operator, Father Francis A. Peterson, in St. Anthony, Idaho, immediately relayed the message to the Idaho State Police, who, in turn, contacted the National Warning System in Battle Creek, Michigan. Hams throughout Montana picked up the messages and quickly contacted the sheriff's offices in Gallatin and Madison Counties, perfectly appropriate because the border of the two counties ran right through Madison River

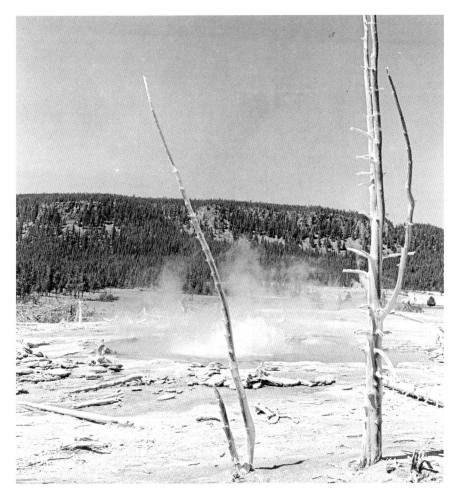

Trees killed by a geyser eruption in Yellowstone National Park. This geyser developed from a crack caused by the 1959 earthquake. *U.S. Geological Survey.*

Canyon, with Gallatin County on the east and Madison County on the west. (Hebgen Dam was in Gallatin County, but the landslide was in Madison County.)

At West Yellowstone's Hitchin' Post Motel, owner Leonard Kelly felt "the whole room swaying," followed by the crash of furniture and dishes. He and his wife were slammed by both sides of the doorway as they tried to exit the building.

"The motel guests didn't check out—they just left," said Mrs. Kelly. "Many had paid for a night or two in advance, but nobody asked for refunds."[18]

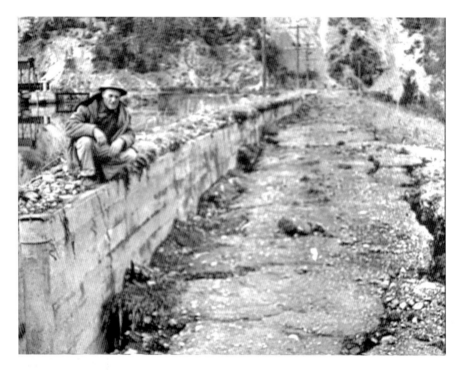

Montana Power workers found serious cracks in the dam. *U.S. Forest Service.*

The fleeing tourists quickly discovered, however, that from West Yellowstone they could not go east (into Yellowstone Park) or north (toward Bozeman) because the roads were destroyed or blocked by boulders. The only escape route was U.S. Highway 191 into Idaho, which was soon jammed with vehicles all heading south, away from the perils of Montana.

Neil Mellblom, a reporter for *Time* and *Life*, wrote that three miles north of West Yellowstone, "the road suddenly resembled a piece of shredded wheat. Asphalt was spread as far as a foot in many places and the driving surface dipped east to west and north to south [and] then back again." Even if drivers could have kept on going, they would have smashed "head-on into a dirt and gravel wall" because the road "dropped abruptly at least eight feet."[19]

Along the northeastern shore of Hebgen Lake, large segments of Highway 287 had dropped right into the lake—some creating thirty-foot crevices—thus trapping any campers to the west because the landslide had blocked the other end of the highway. One couple who had parked their trailer fifty feet from the lake's gentle shore woke to find the trailer rapidly

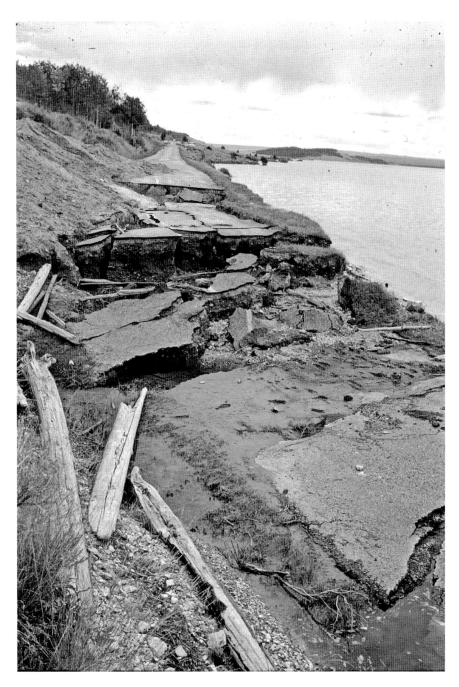

Severe road damage along Hebgen Lake. *U.S. Forest Service.*

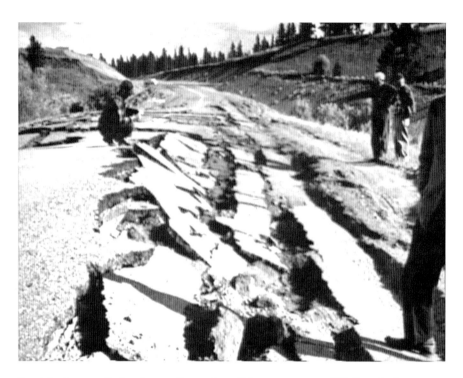

Roads in the area displayed an endless variety of damage patterns. *U.S. Forest Service.*

filling with water. They waded to higher ground and watched as the trailer disappeared. On the other side of the lake, however, the quake had raised the shore eight feet higher, leaving docks and boats stranded on muddy ground.

The wave on the lake spotted by David Bittner was technically a seiche—the lake equivalent of a tidal wave. The quake caused the water in the lake to slosh back and forth, like water in a basin. At the widest part of the lake, twenty-foot-high waves surged and then withdrew about every seventeen minutes. At Hebgen Dam, foreman George Hungerford and his assistant, Les Caraway, watched the effects of those waves: a wall of water four feet high topped the dam for at least ten minutes before receding. Then there was no water visible at all near the dam, as if the entire lake were empty. But ten or fifteen minutes after that, another wall of water gradually approached and topped the dam. George and Les watched this happen four times, with the volume of water flowing over the dam decreasing each time.[20]

The injured victim mentioned by Tony Schreiber was Joseph Armstrong, fifty-two, from Victoria, British Columbia, who was camping in the canyon with his wife, Ruby, forty-five; their daughter, Pat, eighteen; and their son,

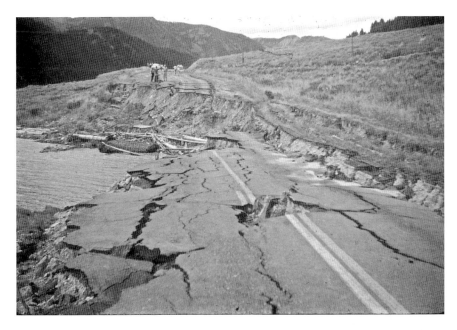

This photo and the one below powerfully illustrate how one segment of highway after another was cast into Hebgen Lake. *U.S. Geological Survey.*

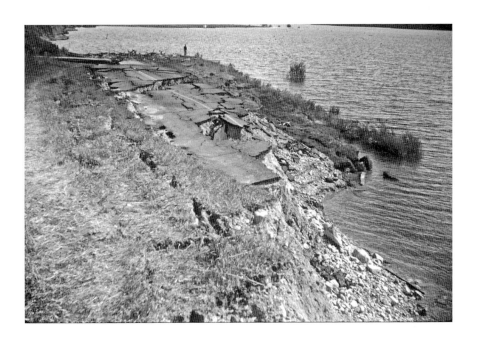

Don, eleven. The Armstrongs' trailer was closest to the slide, followed by the campsites of Margaret and Verona Holmes, the Schreibers, the Steeles and the Painters.[21]

Born in Northern Ireland, Joseph had immigrated to Canada at age twenty, served with distinction in the Canadian Army Special Force and been a detective sergeant in the Saanich Police Department in British Columbia.

Ruby said the first sign of the quake sounded like a plane barreling down from overhead. "I kept thinking, 'This is the end' and then saw a tremendous mass of dirt," she added. "I guess I started to run, and suddenly I was knocked off my feet and rolled and rolled. Then I was swept into the water and began to climb and climb over rocks. I thought I had lost my husband and children. Again and again, I screamed my husband's name and thought it was no use. Then all of a sudden I heard him calling my name. He said the children were OK."[22]

Two campers involved in rescuing the Armstrong family were Doug and Florence Mander, of Idaho Falls, who were staying just below the dam at Campfire Lodge with their daughters, Sybil and Jackie, and with the Rex Bateman family. At the age of seventeen, Doug had been well trained by the Red Cross in lifesaving and first aid, and he and Florence pulled people from the river and helped nurse the injured throughout the night. Doug led a large group of survivors to a spot of high ground quickly dubbed "Refuge Point."

"Someone brought Pat and Don Armstrong to our car," wrote Florence. "They had been in the river and were freezing. Pat had gone through the side of the trailer and had a nasty scratch on her back. I wrapped them in sleeping bags, just hoping for the best. Pat's ankle was wrenched, and she was worried over her parents. She had seen them down below, and her father had been covered with blood. I told her to cuddle down with Don and try to get warm, and I would try to locate her parents, which I did at another station."

When the slide hit, Joseph had been knocked unconscious and pinned under a tree—he would later be diagnosed with seven broken ribs. Ruby had suffered a compound fracture to her leg, and the overpowering wind had driven twigs into her kneecap, a bizarre injury usually linked to tornadoes. "They were both in shock and pain but conscious," wrote Florence. "Mr. Armstrong's ankle was badly cut and his ear was battered and bleeding badly. I told Mrs. Armstrong I would keep the children and that they didn't seem to be badly injured."

A view of Refuge Point on the morning of Tuesday, August 18, 1959. *Photo courtesy of John Owen.*

Teenagers Sybil Mander and Lance Bateman roamed the camp and found bed sheets to tear for bandages. "Among the group I felt the presence of goodness and brotherhood," said Florence.[23]

Anita Painter Thon wrote that the force of the avalanche had cracked the Painter trailer "open like an egg." She and Anne suddenly found themselves in the river, in chest-high, debris-filled water that smelled of gasoline and dirt. Even after getting safely out of the river, the plucky twelve-year-olds returned to the smashed trailer and took turns diving in the foul water in search of their parents, "hysterically crying from fear" the whole time. But, wrote Anita, "when Anne and I were at our worst moment, when we were losing hope and thinking we were going to die, Carole called to us from a ridge above our camp to come to her....We were so happy to see Carole; we just hugged and hugged her."

Anne and Anita found Tootie administering first aid to their mother. Tootie told the girls she needed more bandages because of torn arteries in Myrtle's arm. "We were able to find a large trunk that held some dry, clean items we could use to change her bandages," wrote Anita. "As bad as she was, I never heard her cry or complain about her injuries."

But the question remained: where was Ray Painter?

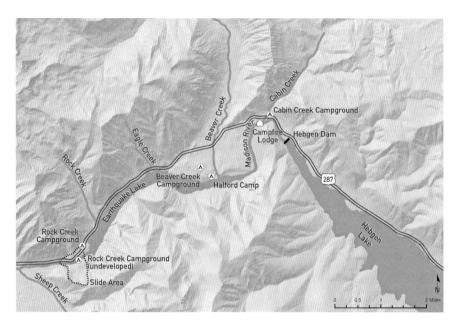

Map 2: Hebgen Lake and the Madison River Canyon. Survivors made their way to the dam or to Refuge Point, located on a rise just west of Campfire Lodge. *Map by Blake Gulbransen, Lee Library, Brigham Young University, from a U.S. Forest Service map.*

Later that day, he told reporters what had happened when the quake hit: "I could hear this rumbling noise and the trailer started to tip. I thought that a grizzly bear was shaking the trailer." He stepped out of the trailer but was catapulted into the air as he reached the last step. "The noise was terrible. I looked up and saw everything was moving, then it occurred to me that it was an earthquake. It sounded so close I didn't know what to do." He tried but couldn't make it back to the trailer. "Suddenly the water mushroomed, and I was hurled back about fifty feet against some trees. A pine tree settled down on me, and a huge boulder fell on my right leg. I could hear my kiddies crying, but there was no sound from my wife."

Seriously injured and unable to move, Ray thought only of his family. "I lay there hoping, crying, screaming, and finally, after what seemed like an eternity, three men came along and lifted the rock off my leg."

Ray was quite likely the man Germaine Schreiber had heard down in the flood, whose yelling and begging had eventually stopped. His clothing ripped off by wind and water, Ray started to limp back toward his trailer, determined to find Myrtle and the girls and ignoring his rescuers' pleas to wait for medical help. Making his way to the trailer, Ray found no trace

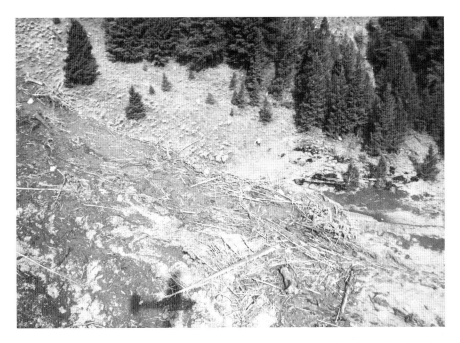

A survivor (upper-mid of photo) waves at an airplane the morning after the quake. *Gallatin History Museum, Bozeman, Montana.*

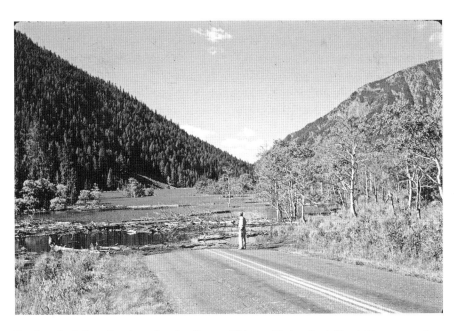

Earthquake Lake a few days after the disaster. This road led to Rock Creek Campground and the mouth of the canyon. *U.S. Geological Survey.*

of Myrtle or his daughters. Nor could he retrieve clothes from the trailer because it had almost vanished in the flood. Then, as he struggled up the ridge, Carole saw him, his leg bleeding heavily. Just as she had with Myrtle, Tootie Greene now got busy helping Ray, tying a tourniquet around his leg to slow the bleeding.[24] The family had finally been reunited, but how long could either Ray or Myrtle survive without hospital care?

3

"OUT INTO THE RIVER"

Frank Martin, a sixty-four-year-old resident of Virginia City, had driven his station wagon over to the canyon to do a little fishing. He was by himself and had no need of a trailer or tent because the car offered a comfortable sleeping spot. On Monday night, he had parked about four miles below Hebgen Dam and settled in for the night.

"I was asleep in the back of my station wagon when it started jumping around, throwing me from side to side," he said. Thinking a big bull moose was rocking the car with his antlers, Frank leaned up and honked the horn to scare off the moose, but the rocking continued.

"I looked over to where another party was camped and saw their tent was flat. Then I knew it was an earthquake."

Frank urged the campers nearby to immediately head upstream to higher ground. Then, rather than going upstream himself, he turned in the opposite direction. "I knew there was bound to be a lot of people below me in trouble as there had been twenty-five cars and trailers parked at Rock Creek Campground, people at the picnic grounds, people and cars strung out along the highway up and down the river."

Not hesitating, Frank drove toward the mouth of the canyon. As he approached Rock Creek Campground, he met a preacher and his family. He sent them to higher ground. "And I told them to pray," he added.

"I saw this old man pinned in the water where a tree had fallen on him and run through his right side. I got him from under the tree and into the back of my station wagon." The injured man was Joseph Armstrong.

Frank then found the Schreibers and Steeles and helped them into the car, which now held six injured victims. "I headed for Hebgen Dam, but the water was over the road. I took a line on the road on the other side and drove in low gear through two feet of water." Next, Frank eased the car around a twelve-foot-thick boulder "round as a baseball" straddling the center line of the road. "Around Beaver Creek the highway had big fissures in it and geysers of water were coming out of some of them, some as high as twenty feet."[25]

At some point in his sorties between the flooded campground and higher ground, Frank joined forces with Robert M. Burley of Billings. Robert and his wife had been camped at Beaver Creek Campground between the dam and Rock Creek Campground when they felt the earthquake. "It was the most terrifying sight I have ever seen," he said. "The car was shaking up and down so violently I thought it would either go in the river or topple over onto us. All around us the trees were swaying with a terrific force, and the ground was trembling violently. The mountain directly across the river from us was covered with dust from the slides. I thought we would be engulfed by tons of rock at any moment."

Knowing a burst dam would flood the canyon, the Burleys grabbed their sleeping bags and camping equipment and drove toward Ennis. They were able to maneuver around several large boulders and rock slides on the highway but found the road blocked by the major slide at Rock Creek.

"There were people on the road waving lights and screaming for help," said Robert. "Many of them were injured seriously and most of them had lost everything in the avalanche. We emptied the back seat of our car, distributing what blankets we had to the injured. Some of them were in a state of shock and were shivering from the cold."

Downstream from the dam—but at a higher elevation—the Burleys found the road jammed and realized that people were organizing a camp at Refuge Point. "We unloaded the survivors into some of the other cars in order to get them warmed up," Robert remembered. "One of the men we transferred had his foot almost severed, and we were afraid to move him. Much to our relief, there was a registered nurse present who helped take care of the injured. We tore up our pillowcases and such to use for bandages."[26]

The nurse was Frances Donegan, fifty-two, of Vandalia, Ohio, who was camping in the canyon with her husband, Fred, fifty; their daughter, Jean, eighteen; and their sons, Clifton, sixteen, and Danny, fourteen. Finding the campsites at Rock Creek Campground all occupied, the Donegans had driven closer to the dam, relishing supper over the campfire and

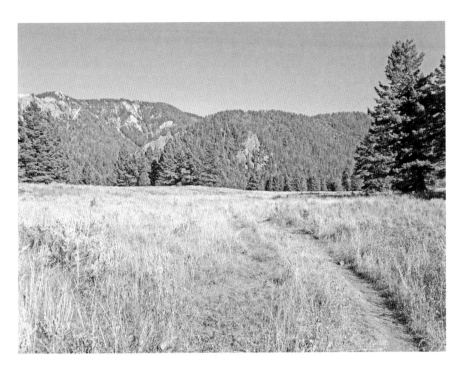

Refuge Point, 2015. *Photo by the author.*

admiring the full moon before retiring, with Fred and Frances in one tent, the boys in another and Jean in the car. Fred and Frances woke to their tent swaying as if it were about to be blown down by a tremendous wind. "I got up to go to my daughter and crashed down again," said Fred. "Then I crawled to the tent flap and saw the station wagon rocking wildly from side to side."

The next thing Fred knew, he saw a foot and a half of water rushing over the road. "At the same time, somebody yelled, 'The dam has broken!' We threw on clothes over our pajamas and got out of there. We left everything—even my wallet, which was under my pillow."

The Donegans joined a caravan of cars heading upstream to Refuge Point, and Fred drove around boulders and small landslides, over cracks in the asphalt and up or down abrupt rises or drops in the road's surface, past the eerie geysers, all the while negotiating a middle-of-the-night traffic jam nowhere near a metropolis or even a hamlet. He had barely parked the car in a haphazard row of other vehicles in a sagebrush meadow when Frances rushed to the aid of several victims.

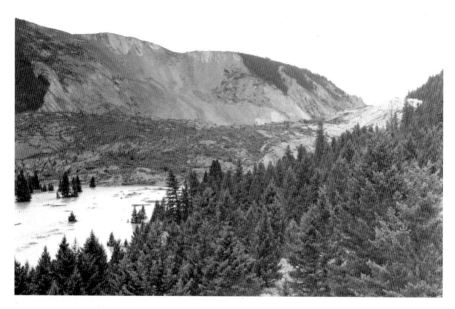

Earthquake lake in its very early stages. *U.S. Forest Service.*

"In all, there were about fifteen [seriously] injured where we were," Frances said. "They were terribly bruised and some were hemorrhaging. We worked with ice, stones warmed at a campfire the men built, torn up sheets and aspirin tablets."[27]

One of her first patients was Joseph Armstrong. He later said she saved his life.

Tootie Greene reached Refuge Point about that same time and set up an aid station in a different part of the meadow. Between them, the two registered nurses served as the emergency medical staff the entire night. In the chaos and confusion, each worked without knowledge of the other until after daylight.

Robert and Frank Martin went back down the canyon. "By the time we got back to Rock Creek Campground," Robert said, "the survivors had built a fire and most of them were up on the road. The campground was completely inundated with water which was backing up behind the avalanche. There were ten to fifteen survivors gathered around the fire, and more were trying to make their way around the avalanche."

Out of the darkness, a woman cried out, "Help me please, my husband is an invalid."

"Where is he?" asked a man at the campfire.

"He's on the rocks near the water," she answered.

The disabled and injured man was Henry F. Bennett (no relation to Irene and Pud Bennett), forty-one, of Cottonwood, Arizona, camping with his thirty-seven-year-old wife and their daughter, Jeannette, fourteen, and son, Royal, ten. Henry was a polio victim confined to a wheel chair. Rocks, mud and water had swept the family right out of their tent and their sleeping bags. With Mrs. Bennett's help, Robert and several other men found Henry and carried him to the road in a blanket stretcher. Then another man appeared, pushing Henry's wheelchair.

The Bennetts had befriended a couple named Ballard from British Columbia whose son was also wheelchair bound. "They're surely dead," said Henry, convinced the Ballards had been lost in the slide.[28]

"We loaded up all the survivors there in two other cars besides mine," said Robert, who had five passengers inside his car and the wheelchair tied

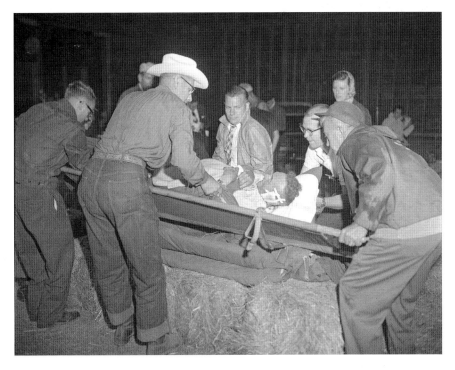

Joseph Armstrong being eased onto a bed at the West Yellowstone Airport hangar used as a triage center. *Utah Historical Society, photo by the* Salt Lake Tribune.

on the outside. "We could hear people who had been caught in the river screaming for help, but we had to leave them for the time being."

Making his second trip to Refuge Point, Robert once again delivered a carload of victims to Frances Donegan's first aid station. He told Fred Donegan and a few others about the plight of the couple stranded in the tree. Determined to rescue the Maults (although none of those present actually knew their name), the men gathered life jackets and rope from other campers and made for Rock Creek, passing a steady stream of headlights aimed at Refuge Point.

Robert and Fred were joined by Frank Martin; David Thomas of Nye, Montana; Charles Rogers of Roundup, Montana; and others whose names were not recorded.

"My job was to watch the car because the water was rising steadily," said Fred. "I had to keep moving the car back."

By this time, even getting close to Rock Creek Campground was a huge task. Robert and the others waded through water for at least a mile before making contact with the Maults. "After splicing our rope together," said Robert, "we went out after them. A man from Nye, Montana [David], whom I was certainly glad to have with us, took the biggest life jacket, a rubber mattress, and headed out into the river on the end of the rope. The other man [Frank] and I waded out as far as we dared to give him more rope; however, he could only get within one hundred feet of the people [the Maults]."

As Robert and Frank tried to bring David back in, the inevitable happened: the rope got tangled in one of the countless trees drifting in the deluge. After trying for an hour and a half, they finally got him free. "He was almost drowned," Fred later said.

"We succeeded in getting [David] back to the fire, where he stayed for the rest of the night," said Robert. "All the while, the ground was shaking, the rocks were sliding and there was a terrible thunderstorm."[29]

Well aware of the efforts of David and the others, the Maults hung on. "While we clung there in the tree," said Grover, "I could see the mountains sliding and falling every few minutes. There'd be a terrific roar followed by more slides. We prayed it wouldn't rain because we were so wet already. It was hazy, thunder, lightning; then it began to rain. It was pitiful. I thought the world had come to an end."[30]

From his spot at the campfire, David continued to shout out encouragement to the Maults and told them the others were going for a boat. Once again, Robert, Frank and Fred drove northeast, toward Refuge Point and Hebgen Dam.

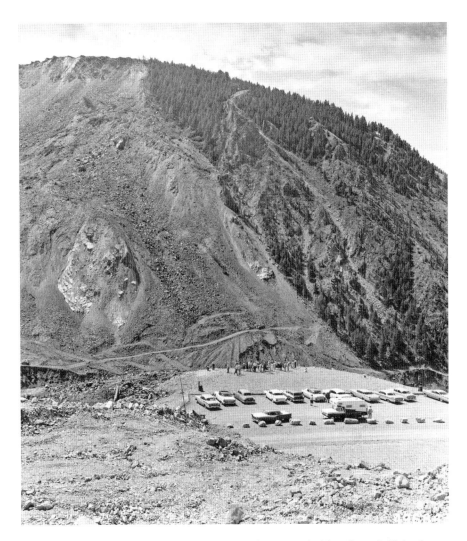

Visitors in 1960 get a dramatic view of how an entire mountainside collapsed. *National Archives, photo by Leland J. Prater.*

Like the Maults, Irene Bennett was summoning all her will to withstand the interminable night. The difference was that she was alone and wracked with both cold and trauma. With no one to reassure her, she relied on her faith. "I sensed a heavenly presence around me and knew He would see me to safety," she wrote. "I remained there [under the tree] praying all night, my heart and the earth keeping an anxious beating rhythm as I endured continuous aftershocks. I called and called my family but heard no answers."[31]

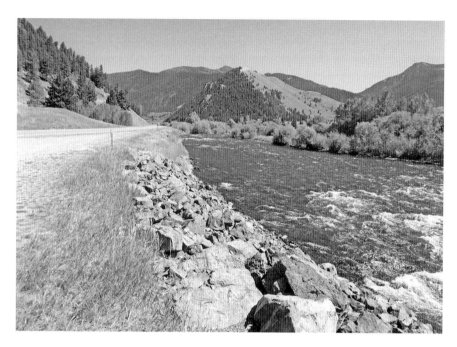

A view of the Madison River near the mouth of the canyon, looking upstream toward the slide area, 2015. *Photo by the author.*

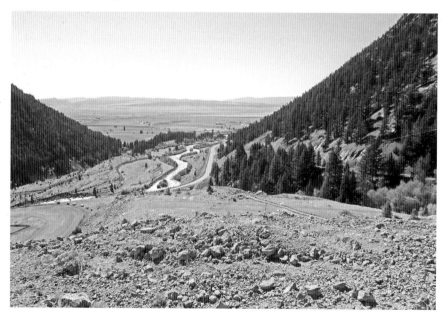

The highway, river and mouth of the canyon, 1999. *Photo courtesy of Bob Nicol.*

Martin Stryker and his brothers had made it safely to Wade Lake. "We arrived at the rustic cabins there to find a bunch of people who were at a loss for what to do," he wrote. "Some of them wanted to get in their cars and try to leave, and others fueled their concerns with spirits and beer. I calmed them down and told them that the roads were problematic in the darkness and that evacuation should wait until daylight. There was no communication with the outside world, and we had no way of knowing what was happening in the surrounding area."[32]

The rattled adults took the sage advice of the fifteen-year-old and stayed put.

4

"A CONFUSED SITUATION"

In June 1955, Hugh Potter, civil defense director for the state of Montana, conducted a surprise alert as part of a nationwide test of civil defenses against an enemy attack. Potter reported that all possible targets in the state were warned of the theoretical attack by police and highway department radios within fifteen minutes of the alert.

Hugh knew that such tests were not popular. "Our people are not too enthusiastic about participating and frankly feel it's a waste of time," he said. "Western people don't want to play war—they want to go fishing or put up a hay crop." Still, Hugh believed preparation was the key to an effective response and was determined to practice.

Fifty-seven years old, Hugh had a wealth of experience as a Montana Highway Patrol captain (and the first Montana officer to attend the Northwestern University Traffic Institute) and Helena police commissioner, not to mention a stint as a young tour guide driving yellow, open-top busses in Yellowstone Park with the acclaimed actor and Helena native Gary Cooper as one of his fellow drivers. Not only that, but Hugh had also lived through a 1935 Helena earthquake that killed four people and destroyed several buildings.

The Soviet attack never came, of course, but in the early morning hours of August 18, 1959, Hugh Potter found that he and other state authorities were indeed well prepared for an emergency. Asleep when the quake shook Helena (140 miles north of the epicenter), Hugh thought it a minor tremor and went back to sleep. At 1:30 a.m., however, Helena city fireman

Ed Cottingham took a police call that earthquakes had been reported throughout the state and that the Hebgen Dam had reportedly failed. Ed called Hugh immediately, and the two of them set up their headquarters in Helena's city hall.

Within minutes, Hugh had called Madison County sheriff Lloyd Brook in Virginia City and Gallatin County sheriff Don Skerritt in Bozeman, both of whom had been awake and on the phone and radio themselves since the quake struck. Hugh also tried to call George Hungerford, the foreman at Hebgen Dam, but the phone was out.

By 2:00 a.m., Hugh had summoned Fred Quinnell, Montana State Highway engineer; Don Brown, of the Montana Fish and Game Department; and Alex Stephenson, chief of the Montana Highway Patrol to headquarters.

"In my years as civil defense director," Hugh would later comment, "the most important thing I did was get to know the right people to call on in an emergency."[33]

Rumors about the dam continued to fly, but at 2:53 a.m., Sheriff Skerritt called back with a report: he had received word from Deputy Sheriff Everett Biggs near West Yellowstone that even though there were still

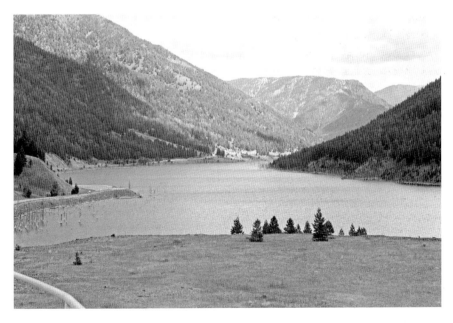

A view of Earthquake Lake from the slide, looking east, 2009. *U.S. Forest Service.*

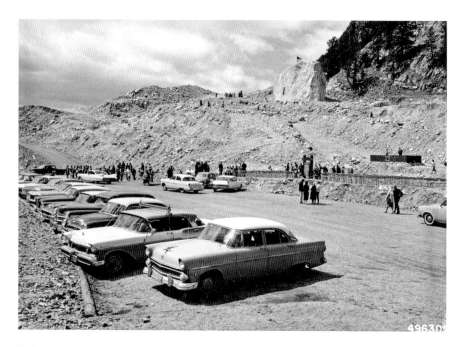

Taken at the close of the 1960 dedication ceremony, this photo shows the slide, memorial boulder, flag, speakers, platform, reserved seats and parking lot. *National Archives, photo by W.W. Gordon.*

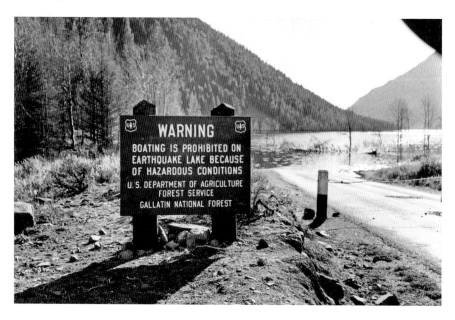

Debris and submerged trees made Earthquake Lake unsafe for boating. *National Archives, photo by W.W. Gordon.*

major aftershocks in the Hebgen Lake area and the lake had gone down considerably, the dam had held so far.

A few minutes later, a reporter for the Associated Press arrived and began asking questions and taking notes. Hugh knew it was going to be a long night and no doubt a long day after that.

One of the first radio calls Sheriff Brook had made after the earthquake was to the Montana Highway Patrol office in Butte, requesting the help of patrolman Glen Stevens, forty-two, who lived in Whitehall (sixty miles west of Bozeman and twenty-six miles east of Butte). Fearing that Hebgen Dam might fail, Brook knew that residents throughout the Madison River Valley must be warned, but he also knew that phone service in the area had been knocked out by the earthquake. Brook trusted Glen and also knew that by driving south from Whitehall toward the Madison River Canyon, Glen would have the perfect opportunity to sound the warning.

"I was still up when the quake hit," said Glen. "Not long after that, I got the call from Butte. The first thing I did was call Dutch."

"Dutch" was Oscar E. Buhl, forty-one, a friend of Glen's and a Jefferson County deputy sheriff who also lived in Whitehall. Glen picked Dutch up in his highway patrol car. A couple phone calls later, they were accompanied by Hector Baldwin, Madison County undersheriff, and game warden Gene Todd. Hector and Gene rode in a panel truck with higher clearance than the patrol car—something that would come in handy on rough roads.[34]

By the time the four men reached Highway 287 and headed south, contradictory rumors about Hebgen Dam were flying over the radio waves and phone lines. The complicated nature of the communications chain was ripe for misunderstanding, as the following excerpt from a Montana Power Company (which owned and operated the dam) report shows:

> At about 12:30 AM Tuesday, August 18, the Montana Power Company system dispatcher at the Butte Hill substation received a call from the Butte Sheriff's Office, saying that the earthquake had caused a failure of Hebgen Dam and the water in the lake had gone down about 10 feet. This information came through the Virginia City Sheriff's Office from an Idaho sheriff near or at Pocatello, Idaho, by telephone. The Idaho sheriff had received the message from a ham radio operator somewhere in Utah or Idaho who had picked up the message from Harold Young, another ham operator at West Yellowstone.[35]

Eighty-five miles east of the dispatcher in Butte, a Bozeman dispatcher was also hearing rumors. Highway maintenance employee Frank Maykuth had come on duty at midnight, twenty-three minutes after the earthquake. Reports of minor rock slides and rocks on the road came via both phone and radio from Three Forks, Livingston and Bozeman Hill. All of this was fairly routine, indicating nothing more than minor tremors. That changed at 1:50 a.m., when Frank was contacted by a maintenance man stationed at Duck Creek Junction, eight miles north of West Yellowstone. Frank then made his first log entry that hinted of the seriousness of the earthquake: "Phone call from Austin Bailey at Almart Lodge 50 miles south of Bozeman who gave sketchy report of damage done by earthquake in West Yellowstone area. Bert Moore and [George] Barrett came to the office immediately and started checking on the situation. Bailey instructed to continue with family on to Bozeman."

Severe shaking and the sound of furniture jumping out of place had woken Austin, who found his lights were out as he checked on his wife and children. Correctly concluding that the earthquake had tumbled

During 1960, 367,000 people visited the earthquake area. *National Archives, photo by Don Fritts.*

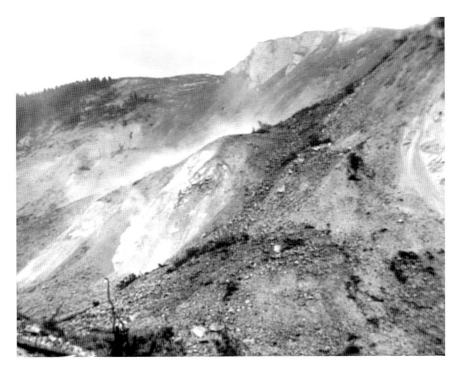

Eyewitness testimony indicates that the mammoth avalanche lasted less than a minute. *U.S. Forest Service.*

rocks onto road, he went out to his car to check the highway. He had barely started when the road suddenly dropped out of sight—he slammed on the brakes as the station wagon skidded down a fifteen-foot scarp created by the earthquake. Rattled but unhurt, Austin knew he had to contact the highway department as soon as possible. That was easier said than done, however, because the phones were out and the radio in his truck was either on the blink or unable to reach headquarters in Bozeman.

Going north was the only alternative: the road south to West Yellowstone was impassable—a reality made clear by an overturned Cadillac that had hit the same scarp as Austin. So he packed up his family and drove carefully on what was hardly recognizable as Montana State Highway 191, with both vertical and horizontal fissures making a mish-mash of the asphalt and boulders frequently blocking the way. Considering these conditions, he made excellent time, reaching Almart Lodge—forty miles from his house and ten miles south of Big Sky—in about an hour and fifty minutes. Here he finally found a working telephone.

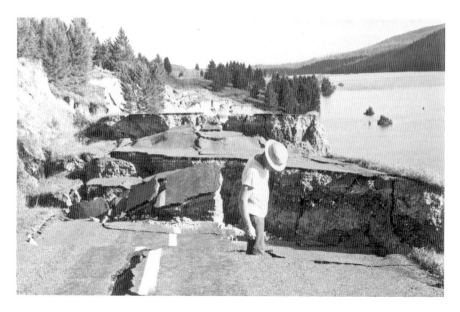

Reports of the ground "opening up" were hardly exaggerations. *Gallatin History Museum, Bozeman, Montana.*

At 2:00 a.m., ten minutes after taking Austin's call, Frank noted that reports were coming in from a variety of sources "regarding the evacuation of the valley people and the failure of the Hebgen Dam." Frank then contacted the Montana Power Company in Bozeman and was told that "the status was indefinite at that time."

The power company was wisely avoiding jumping to conclusions. At 2:35 a.m., a message was relayed to Frank from Montana Power president Jack Corette "that it was unlikely that the dam had failed" but that Frank would be updated as soon as possible. At 3:00 a.m., Jack assigned vice-president C.H. Kirk and power superintendent R.R. Rend to arrange to fly over the dam in the company plane and investigate.

At the same time that Montana Power officials were making these plans, Glen Stevens's radio calls were being relayed to Frank, who noted that "Patrolman Stevens was being alerted at all times to the possibility of the flood condition" and that "Stevens continued his journey reporting in at various intervals to the effect that everything was normal."[36]

As for Glen and his companions, they had reached Ennis (fifty miles south of Whitehall) at 2:30 a.m. With a population of about six hundred people, Ennis—fourteen miles east of the county seat of Virginia City—was the largest town in the Madison River Valley and was at extreme risk of flooding if

the dam broke because it was situated on the banks of the Madison. (Virginia City was not at risk because of its considerably higher elevation.) As Glen and the others passed through the sleepy town, however, all was quiet.

A little after 3:00 a.m., the four men reached the Kirby's Ranch, a popular fishing resort along the Madison River about twenty miles south of Cameron that included a lodge and two cabins. Otto Kirby, the resort operator, had already warned the cabin guests to leave but told Glen there were also two house trailers parked near the river. Glen and Dutch woke the owners of the trailers, who immediately made preparations to leave. Then the foursome filled the vehicles with gas from Kirby's pump.

The highway south of Kirby's Ranch was blocked by boulders, so Glen decided to cross the Madison River on Hutchins Bridge and then proceed south on a gravel road that ran along the west side of the river. He radioed a report to Sheriff Brook that the Madison was muddy but otherwise OK and also told of his plan to continue on to the Madison River Canyon.

"Don't do it!" the sheriff shouted over the radio. "The dam's broke, and you'll get killed. Come back!"[37]

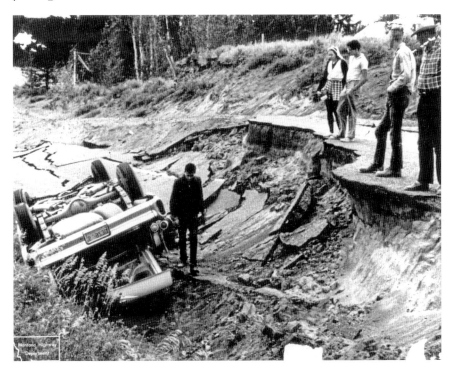

In the hours immediately after the earthquake, drivers fleeing the scene were taken by surprise by steep scarps. *Gallatin History Museum, Bozeman, Montana.*

But had the dam really ruptured? Frank summed things up in his log, writing that the "various and sundry reports of the condition of the dam, flood water, etc. from natives living further up the Madison all added up to a confused situation."

The log continued: "Stevens relayed that the dam was out and [he was] coming back out of [Madison] County ahead of the water. This was approximately 3:15, at which time John Krauss, county commissioner, of Ennis was alerted, as well as Butte and our Helena office."[38]

Monitoring multiple radio frequencies, Hugh Potter had heard enough. He radioed Ennis marshal George Hibert and urged him to evacuate the town. Minutes later, a prolonged blast from the town fire siren jolted citizens awake, and volunteer firemen hurried to the fire department. Told of the impending flood, they rapidly spread the news by word of mouth—neighbors were soon warning neighbors who honked their car horns and warned others.

"This dramatic persistence of the siren had never before happened in Ennis," wrote Ennis physician Ronald Losee. "We all hurried out of the house to watch the fire truck drive east on Main Street." But the fire engine

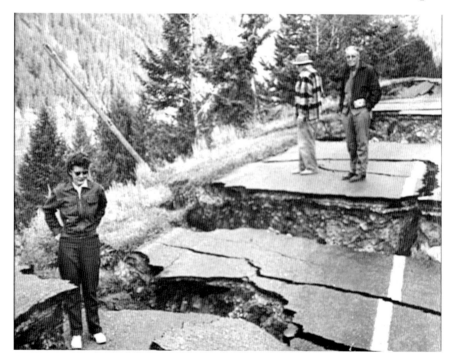

Curious visitors were constantly reminded of the illusion of "solid ground." *U.S. Forest Service.*

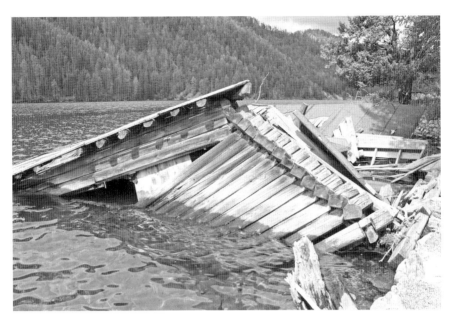

Remnants of a cabin on the shore of Hebgen Lake, not far from the dam, 2009. *U.S. Forest Service.*

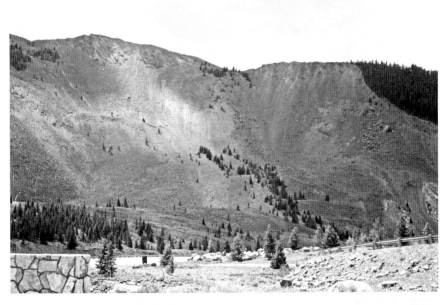

The slide area at the time of the fiftieth anniversary of the disaster, August 2009. *U.S. Forest Service.*

didn't leave town. "Instead it turned south at the corner of Hal Pasley's garage, blowing its siren as it careered down the four 'city' blocks to the end of town, turned west going the one block available in that direction, then north back to Main street again. It kept circling and screaming."[39]

Even without phone service, the entire community was promptly awake and alert.

"They wake you up in the middle of the night with the story that the dam's going to go," said Ennis old-timer Ray "Tuffy" Kohls. "Still, the people packed up and got out in pretty good order."

In what was undoubtedly a once-in-a-lifetime event, Ennis residents saw the country town bustling with traffic and noise and good fellowship at four o'clock in the morning. According to one report, "overstuffed furniture and horses and cows were among the items evacuees took along."

Some families drove northwest toward Butte, others west to Virginia City, and others took refuge on a hill overlooking Ennis itself, where a case of Jack Daniel's whiskey was supposedly put to good use. Highway patrolmen set up road blocks and drove through town with sirens blaring.

Meanwhile, Glen, Dutch, Hector and Gene were presumed to be returning to Ennis—at least according to the latest radio report. That plan never developed, however. None of the four explained what discussion, if any, they had about turning around—we simply know they continued south.

"Every turn we got off that bench," said Glen, "I thought we were going to meet swimming water."

Only minutes later, Sheriff Brook radioed another alert: a fisherman who had made his way out of the earthquake area reported that two people had been killed at Cliff Lake, fewer than ten miles from Glen and Dutch's current location. Glen now drove on with new resolve, determined to help quake victims, come hell or high water.[40]

TOOTIE GREENE AND HER SON, Steve, had been given a ride to Refuge Point by Gil Gunderson from Bellevue, Washington, who was camping in the canyon with his nephew, Jimmy Willey. Ray had caught a ride with one of the many good Samaritans whose names are no longer known. By now, Tootie and Ray knew that their car and tent and everything else—except a salvaged trunk of clothes and odds and ends—had disappeared into the new lake. "No matter," Ray had told Tootie, "we've still got each other and Steve."

Gil and Jimmy had carefully lifted Margaret and Verona Holmes into the back of the station wagon, where they lay side by side during the trip up the wrecked road that seem to take forever. Gil drove as carefully as he could,

but each jolt from rocks or gaps in the highway brought fresh pain for both mother and daughter.

Ray and Tootie were reunited at Refuge Point, and the two of them worked together, helping the injured in any way they could. "I used sheets and towels for bandages, a plastic sheet for ice bags and an ice cream container for a bedpan," she said. "And, of course, campers and cars became the resting places for the injured." Luckily, station wagons, campers, trailers and sleeping bags were plentiful, as was ice from the many coolers on hand.

"Blood plasma was the one thing we didn't have that would have done the most good," said Tootie.

Gil and Jimmy took care of Steve as Tootie turned first to Margaret, who had suffered three severe body wounds, a serious head injury and cuts all over her body. Keeping Margaret in Gil's station wagon, Tootie bandaged her wounds as well as possible, had an air mattress placed underneath her and covered her with blankets.[41]

Tootie next examined Clarence Scott, a fifty-nine-year-old retiree from Fresno, California, and his wife, Olive. The Scotts loved vacationing in the canyon, and this was the fifth year in a row they had parked their trailer at Rock Creek. They were practically permanent residents and had been at the campground since June 7. On Monday night, they had enjoyed a delightful dinner in the Maults' trailer and then returned to their own trailer next door, with the Painters on the other side.

"We were in our house trailer asleep," Olive would later tell reporters from her hospital bed. "There was a terrific shaking and a loud noise. It sounded like a thousand winds going through a thousand trees, but not a tree was moving."

Something rammed the trailer against a tree, and the Scotts' "home" disintegrated, the side and back of the unit both vanishing.

"My husband was gone," she said. "Then I fell out. It was horrible. Children were screaming and crying for their mothers. And husbands were begging their wives to answer."

One survivor yelled for someone who could swim to help. "I looked where there had been trailers and tents," Olive added. "There weren't any."

Clarence had been struck by a tree and hurled into the rocks and mud but was standing when Olive found him. "We started walking. We went past one woman whose leg was sticking in the air. I asked her if I could help. She said her leg was broken. We got in someone's car and went to high ground."[42]

Tootie was surprised that Clarence had been able to walk a short time earlier. He was gravely injured, with serious lacerations and a broken collar

bone and, Tootie concluded, internal bleeding. His thumb had almost been torn off. She bandaged his wounds and tried to make him as comfortable as possible. "Olive knew she wasn't up to par, but there was nothing visible that I could tell," Tootie said. She had Olive rest and found out later that Olive had a ruptured bladder.

A family who had escaped unhurt offered their house trailer for Ray and Myrtle Painter, neither of whom was doing well. Despite efficient bandaging, their wounds continued to slowly bleed. Along with an arm that was nearly severed, Myrtle had a crushed chest. Ray had a bone-deep gash down the length of his thigh. "Without sleep or rest, she was around checking on us and the other injured every few minutes," Ray said of Tootie.

When Dr. Reed Quesnell, a dentist from Arcadia, California, told Tootie he had a small amount of codeine, she administered it at once to Myrtle and Margaret, the two most seriously injured patients. Several others were in severe pain, but aspirin would have to do. Dr. Quesnell was a World War II veteran, but he told Ray that he had never seen such gruesome injuries before.[43]

Tootie Greene (left) and another woman attend to victims lying in a station wagon. *U.S. Forest Service.*

Anne and Anita Painter were not allowed to see their parents for fear the shock would be too great, but Carole assisted with their care, even though her injured eye would eventually require surgery. Strangers took care of the twins and tried to comfort them.

"Anne and I had on white flannel pajamas that originally had little tiny blue flowers on them," wrote Anita. "They were now covered with black dirt, gasoline and blood. The smell made us sick, and we couldn't wait to be able to get cleaned up."

Many families at Refuge Point had survived the mayhem without a single injury, and some of the children were playing. Some were even having a snack or an early breakfast, but not Anne and Anita, who were too worried about their mom and dad to eat.[44]

"It started raining and people sought shelter in any car they could fit into," wrote Florence Mander. "With so many of them having lost their cars, tents and trailers, it seemed every car was packed. Everyone waited for daylight and hoped no great tremor would come, at least not until it was lighter. Some people dozed in their cars, and most of the children slept. The

Four-wheel-drive vehicles proved quite valuable in the aftermath of the earthquake. *U.S. Forest Service.*

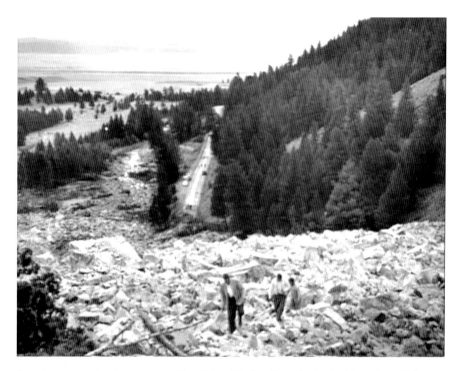

Searchers scour the downstream side of the slide for clues of who had been lost. *U.S. Forest Service.*

camp was extremely quiet. By now, we were all getting used to the ground pulsing. It was like getting used to the deck of a ship."[45]

Tootie was glad for the rain because the thunder drowned out the noise of the aftershocks. The long night seemed to go on forever. Tony Schreiber and his friend Warren Steele had both slipped into serious shock. Tootie gave them liquids and kept them warm. Nor was anyone else in the Holmes group doing well. Margaret was racked with pain and seemed close to death; Verona's ankle was shattered—it would trouble her continually until she died in 2004. Germaine's body throbbed from abrasions, cuts and bruises. The gash near Bonnie's right eye would threaten her eyesight and require almost three dozen stitches; Esther had a broken back and a broken leg, leaving Tootie and others to wonder how she possibly rescued Margaret.

"I really do think I was intended to be there," Tootie said decades later. "I don't think we plan our lives. Our lives are planned for us."[46]

5
"THE SALVATION OF MANY"

By around 5:00 a.m., the great majority of survivors were clustered in several camps between Beaver Creek and Hebgen Dam, most notably at Refuge Point. Thus far, thanks to Tootie Greene and Frances Donegan and all those assisting them, there had not been a single fatality on the east side of the slide. Not only that, but these erstwhile vacationers were intimately aware of two crucial circumstances unknown to the outside world: first, the dam had held; second, a mammoth landslide had blocked the canyon, dammed the river, injured scores and entombed an unknown number of cars, trailers, tents, dogs and men, women and children.

In the coming days, officials would gradually unravel the mystery of what really caused the blaring of the fire alarm in Ennis. It seems that Jack Hallowell, owner of a drugstore in Pocatello, Idaho, had been staying near the southeastern edge of Hebgen Lake. Right after the earthquake, Jack had walked down to the lake to find a waterless shoreline. Indeed, the lake itself—as far as he could see—had disappeared. The earthquake had destroyed Hebgen Dam—that was the only logical conclusion. And Jack's reaction was not only understandable but commendable: he climbed in his car and somehow threaded his way from the Duck Creek Junction to West Yellowstone, on the same stretch of "impassable" Highway 191 that had overturned a Cadillac and sent Austin Bailey and his family scurrying north to Bozeman.

What Jack did not and could not know was that the shifting of the earth and the course of a tidal wave had temporarily emptied his side of

The Donegan family not long after their return to Ohio. *From left to right*: Frances, Jean, Clifton, Danny and Fred. *Photo courtesy of Dan Donegan.*

the lake. Rather than assuming there was nothing he could do, he put himself at considerable risk to sound the alarm. When he finally reached West Yellowstone and learned the phone lines were down, he managed to locate ham radio operator and owner of the Westwood Motor Lodge Harold Young. Harold made contact with a radio caster in Blanding, Utah, who contacted another in Idaho, and so on and so on, with the daisy-chain of communication eventually reaching Sheriff Brook in Virginia City and Hugh Potter in Helena.[47] Yes, the evacuation had been a mistake, but in its own way, it had been praiseworthy.

While radio transmissions were bouncing from one state to another, the surprised folks of Ennis found themselves possibly bidding their homes farewell and Tootie and Frances cared for the Painters, the Holmes and the Armstrongs, the Maults were trapped in the tree, hanging on for precious life, the only survivors on the east side of the slide who had not been brought to safety. Luckily, they were not alone. David Thomas and others had kept the fire burning and continued shouting encouragement to the weary and worn-out couple. There was still hope that Robert Burley, Frank Martin and Fred Donegan would return with a boat. There was still hope that daylight would find Grover and Lillian alive and fighting for life.

Not far from the Maults, and unknown to those at Refuge Point and elsewhere, a small group of people had gathered on the side of the mountain opposite the slide. They had scrambled to higher ground in the wake of the flood and now had no cars or trailers or even access to a dry road, not to mention a nurse to administer first aid to those hurt among them. None of that mattered, though, because they had all survived, when one of them could have easily been lost in the murky water now threatening the Maults.

The Reverend Elmer H. Ost, a pastor at Bethany Congregational Church in Queens, New York, had brought his family on a countrywide camping trip, traveling from New York City through Ontario and upper Michigan to North Dakota, where they met up with some of Elmer's family who lived in Seattle. They then continued on Montana's Glacier National Park, said Elmer, "where we visited and looked at the glories of the park."

After the Seattle relatives returned west, the Osts stayed on for three or four days before pushing south to Yellowstone. "In those four days we met the Melvin Frederick family from Elyria, Ohio, at the home of

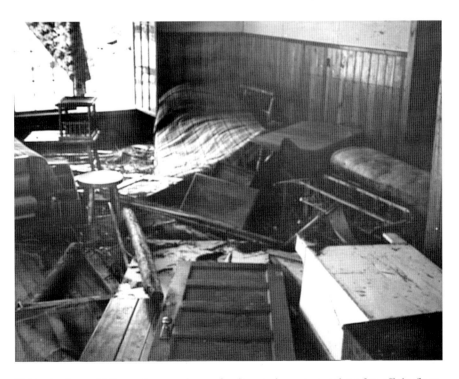

Cabin dwellers said the quake caused some furniture to jump two or three feet off the floor. *U.S. Forest Service.*

the Rev. Ralph Werner of Columbia Falls [Montana]," wrote Elmer, "and decided that we would probably stay together camping Monday night [August 17, 1959] and seeing Yellowstone Tuesday. They had two children about the ages of our older children, and a cousin, so we were glad to have congenial company."

With Elmer, forty, were his wife, Ruth, and their children: Larry, fourteen; Geraldine, thirteen; Joan, eleven; and Shirley, six. Their new friends, the Frederick family, included Mel, forty-three; Laura, forty-five; Melva, sixteen; and Paul, fifteen. A nephew, George Whittemore, fifteen, was also with them. He was staying with the Fredericks while his parents, Mr. and Mrs. Willard Whittemore, served as missionaries in west Pakistan.

The Osts and Fredericks left Columbia Falls Monday morning for the 350-mile trip to the Madison River Canyon. They didn't try to travel together but took the same route and agreed to meet that evening at Rock Creek Campground. They drove through Kalispell, Missoula and Butte and lastly followed Highway 287 through Ennis and up the wide Madison River Valley, thoroughly enjoying the panoramas of mountains, foothills, meadows, lakes, rivers and perfectly blue "Big Sky" that Montana is famous for. The two families even passed and waved at each other a few times during the pleasant trip.

The Osts arrived first, around 6:00 p.m., but couldn't find two spots together at the western end of the campground (where Irene and Pud Bennett and their children would camp), so they continued on to the eastern section and reserved places for themselves and the Fredericks (upstream from and not as close to the river as the Armstrongs, Holmes and Painters). The Fredericks arrived shortly thereafter.

"We had a very simple supper and took out only what we needed for sleeping from our cars since we planned to be up at six, eat cold cereal, pack the cars and head for Yellowstone," said Elmer.

Both families got to sleep around 9:30 p.m., with Elmer, Ruth, Larry and Geraldine in a tent; Joan and Shirley in the Ost car, a 1950 Buick; Mel, Paul and George in a tent; and Laura and Melva in the Frederick car, a 1958 station wagon.

"It was about 11:38 when the quake struck," said Mel. "At first I thought it was a bear tearing through the nearby trees. Someone shouted, 'It's a tornado or an earthquake!' There was a tremendous roar. Outside the tent, and looking upward, I saw the whole side of a mountain collapse. It looked like a huge waterfall. There was a gush of air, followed by a wave of water from the Madison River."

"I was startled by a thundering noise and a commotion in and outside the tent," said Elmer. "Ruth and Geraldine jumped up and ran out of the tent and shouted about the bear as they went. I was behind them and less awake when I came out. Ruth was screaming, 'It's a cyclone!' and was glancing about in terror."

Elmer saw the tent and trees swaying but felt no wind. The Buick rocked "as if men were jumping on the bumpers in rhythm." Then the brake lights came on—Joan had slammed on the brakes because she thought someone was trying to move the car.

"I then became aware of a thunderous roar, as though several express trains were thundering within a few feet," said Elmer. "I heard rushing water. I cannot say what I saw or sensed, but I hollered out, 'Hold on to a tree—it's a flood!' and ran to the nearest tree. Then the tidal wave hit; I held on and pulled as high as I could and was safe. The car at my left shot backward toward the east. Then the swirling water, the rushing wind and flying debris stopped."

For Elmer, it was a "dark, confused moment, the end of the first terror," that was followed by a second one of observation: "The tent was gone, the cars jammed together. Where were the people, and especially, was our family safe?"

He found Joan safe and dry on higher ground, Geraldine wet and with a bleeding hand but otherwise OK, Ruth and Shirley safe in the car (now surrounded by knee-high water) and Larry drenched but all right.

"While I searched for my family," he said, "others were screaming, children and adults. I helped some adults, tried to comfort two children who screamed about their mother in their trailer"—probably Anne and Anita Painter—"and heard the strong cry of a man on a trailer top [Grover Mault] but didn't dare wade in to get him in the darkness and deep water."

At that instant, Elmer heard Mel Frederick call for help for his son, Paul. Elmer got a flashlight from someone and tried to get oriented in the alien landscape. Nothing looked like it had earlier. He circled his own car and the trees jammed against it and found Paul sitting on the ground about five feet behind the car's rear bumper, water covering his legs. Paul was pinned to the ground by a pine tree about ten inches in diameter that lay across his thighs. Elmer followed the tree with his flashlight and saw that one end of it was lodged under his car. A second tree, also stuck under the car, was up against Paul's back, about a foot off the ground. Paul didn't seem to be hurt bad, but he couldn't budge.

Again, Elmer probed with the flashlight, this time discovering that the other end of each tree disappeared under a smashed trailer. He and Mel

held Paul's arms and tried to pull him out. Paul shrieked in pain, but they hadn't moved him at all.

"Let's see if we can move the logs," said Mel. They tried, but, as Elmer said, "the logs were solid."

Elmer checked the water level: it had risen conspicuously in just a few minutes.

This time they tried to leverage the logs with tree fragments cast up by the flood. Again, no luck.

Searching through the debris, Mel found a long plank filled with spikes. He tried to pry the logs apart and moved them an inch or two but not nearly enough to free Paul.

"My legs are getting numb," said Paul. "I think the pressure on my back is paralyzing me."

The water was rising fast now. Both logs were under water, and Mel and Elmer "were working by feeling only."

They tried the plank again to no effect. The cold water was up to Paul's chest. All around them, people were either too hurt to help or were searching for their own loved ones, and Mel and Elmer were considerably hindered by being barefoot.

"As the water rose to Paul's neck," said Elmer, "the panicky realization that if we couldn't free him soon we would see him drown in our arms nearly overcame me. We were increasingly helpless as the water rose, floundering, working by feel, and could find nothing to help us in the deepening water."

Mel stayed calm, even though the water was up to Paul's chin and he was spitting water and trying to hold his chin higher. Paul uttered a prayer and then said, "I'm ready to go; God must want to take me home."

"His courage was a strength to me, but the fact that he too realized what was happening unnerved me more," said Elmer.

Elmer called to Mel: "We've got to pull as hard as we can—even if Paul cries or we pull his arms out of joint." The two of them pulled together.

"To our amazement," said Elmer, "he rose six inches higher in the water. The rising of the water had made the logs and the trailer buoyant. We worked feverishly, and in a few seconds, we found that the rising water and our pulling had Paul standing free between the logs, able to use his legs and completely safe. We all breathed a prayer of thanks, shouted the news and got to higher ground near the highway."

"I thought Paul was doomed to death," said Mel. "I prayed hard. There was a miracle, for as we gave one last all-out effort we pulled him loose. Prayer was the salvation of many."

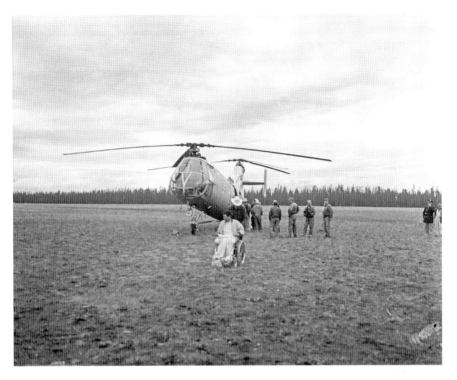

Henry Bennett is assisted at the West Yellowstone Airport. *Utah Historical Society, photo by the Salt Lake Tribune.*

The confusion of the scene could hardly be comprehended. The man on the top of the trailer was still yelling for help. A car with a trailer on higher ground moved out onto the highway. At other cars, people began loading victims to take to the dam. Mel and Elmer helped carry a woman with a broken ankle—Verona Holmes—to one of the cars. Minutes later, a woman pleaded with Mel and others to help her husband, who was disabled. Mel thus joined Robert Burley in the rescue of Henry Bennett but didn't know either of their names.

"Several of us huddled on the highway," said Elmer, "some dry, some wet, some without any clothes except pajamas, half of us without shoes. The Frederick group and ours were complete, although one in each group had a bruised and bleeding eye." The two with eye injuries were Ruth Ost and George Whittemore. In addition, Paul and Geraldine Ost had both injured a hand, and everyone had scrapes and bruises.[48]

At some point, another person joined the group: Mary Bair of Stone Mountain, Georgia, who had been a dinner guest, along with the Scotts,

of the Maults the previous evening. She was staying in the trailer by herself because her husband, Eugene, had gone to Helena for medical treatment.

"The bed began to shake. Then I heard a roar that got louder and louder," she said. "Then the water started coming in through the roof. The whole front of the trailer started caving in toward me. The windows broke. Everything inside was tumbling and breaking. You do crazy things at a time like that. I grabbed my car keys and billfold and crawled out through the front window."

The car keys did her no good because her car was already caught in the flood.

"Trees were falling all around," she continued. "Everywhere people were screaming and trying to wade out of the water."[49]

She had suffered only minor injuries, a good thing because the friends she would have called on for help—the Maults and Scotts—were nowhere to be seen and could not have helped her in any case. Fortunately, she was befriended by the Fredericks and Osts.

Mel and Elmer were about to build a fire on the road when they heard the dam could go at any time. "We stumbled up the sagebrush hillside about 150 feet and found a fairly level open spot," said Mel.

As they climbed to the ridge, the Osts and Fredericks were joined by Elsie Moore and her two nieces and two nephews of Spokane, Washington, and Lewis and Ann Smith and their daughters: Joann, eleven, and Carol, seven. Both families had tried to get out of the canyon to Ennis but had found the road blocked by the slide. Convinced the dam was about to burst, they abandoned their cars and clambered to higher ground. "Climb, climb, climb!" Lewis Smith shouted to Ann and the girls.[50] Between them, however, Elsie and the Smiths brought "groceries, a camp stove, sleeping bags, air mattresses, cooking utensils, three suitcases, and a 9' by 12' plastic tarp," all of which would prove invaluable.[51]

The group of four families and a single woman totaled twenty-one people. A few days earlier, none of them had known the others. Now they helped one another up the hill in unique camaraderie and built a fire. "We huddled around the blaze and dried blankets, jackets, shirts, took off our clothes without undue modesty to dry them better," said Elmer.[52]

A VERITABLE FLEET OF PLANES flew over the earthquake area early Tuesday morning, but four deserve special notice. As mentioned earlier, by 3:00 a.m., Montana Power Company officials had decided to send Cecil H. Kirk and Robert R. Rend to investigate the condition of the dam. They boarded a

twin-engine Beach in Butte around 4:00 a.m. for the one-hundred-mile flight to Hebgen Dam; the pilot was Jay Mooney. Jay flew east and then followed the Madison River south. All the way to Kirby's Ranch, everything looked normal. As they approached the mouth of the canyon, however, they could no longer see the reflection of the river. Rather than flooding the valley, the Madison had vanished.

Jay banked the plane and returned for a second look; again, "they saw that the river bed was practically dry, not the raging torrent they had expected to see." Minutes later, "they saw that the top of a mountain had slipped into the valley, completely damming up the Madison River."[53]

The three men thus became the first outsiders to see the slide and understand the dramatic impact of the earthquake. Because of difficulties making radio contact, however, they were not the first to get the word out. After inspecting the dam and concluding it would hold, they flew on to the West Yellowstone Airport, which soon would be the busiest small airport in the United States.

At three thirty that morning, after meeting with Hugh Potter, Montana Fish and Game Department head Don Brown had called the department pilot, Ralph Cooper. Don explained the uncertainty about the dam and asked Ralph to make a reconnaissance of the canyon as soon as possible.

Ralph got to the Helena Airport as fast as he could and prepared the Piper PA-18-150 Super Cub for flight; he flew off on the 125-mile journey between 4:30 and 5:00 a.m. He monitored ground radio traffic on the way and at one point heard a highway patrolman urging Sheriff Brook to make sure that "this man with me is deputized formally as it might make some difference to his family in case we don't get out." The call had come from Glen Stevens, uncertain he would survive and looking out for the welfare of Dutch's family.

At 6:00 a.m., Ralph radioed his first report:

> *Slide area 43 mi. so. of Ennis. White sign on top of dam reading SOS OK. Road has gone into the lake on the road side. Mountain has gone into the lake on the opposite side. Cracks 6' to 8' wide across the road. Slide is estimated to be ½ mi. long and 300–500' deep. Water rising very fast. About 50 cars stranded in the area. Estimated 150 to 200 people. The only way out is by a helicopter.*[54]

"I am very encouraged," Hugh Potter said when he saw Ralph's report. "It is the best news yet. The evacuation is finally getting underway."[55]

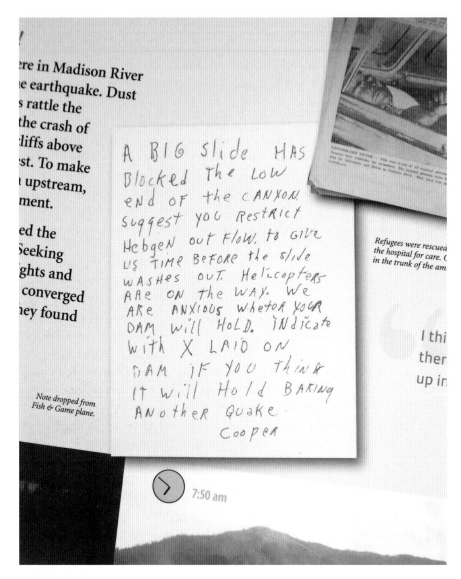

Early Tuesday morning, Fish and Game pilot Ralph Cooper dropped this note for George Hungerford, Hebgen Dam caretaker. *U.S. Forest Service.*

Ralph had reached the canyon about 5:45 a.m., right around daybreak, about an hour after the Montana Power plane flew over the area. (The official time for sunrise that morning was 6:29 a.m.) The Fish and Game aircraft was apparently the first plane seen by most of the survivors. Ralph flew at a low altitude and made several passes.

Florence Mander described the scene:

Finally, after what seemed an eternity, the sky began to show the faintest signs of daylight. Again movement started among the people and again it seemed as if hope and faith took possession. The tremors still kept coming at intervals, but with the daylight, they didn't seem so bad....Some of the men set up three camp stoves on a camp table and we were in the cafeteria business. It's hard to believe now how smoothly and fast all were served. Bacon, pancakes, and coffee....A plane came in over the trees and people raced like mad, waving their arms in the air, shouting and laughing. Such happiness I have never felt before. At least we knew someone knew we were here. They dropped a note instructing us to take all the injured up to the dam because a doctor would be brought by helicopter and would land at the dam.[56]

About six miles downstream from this activity at Refuge Point, the group led by Elmer Ost and Mel Frederick was having a remarkably similar experience, as Elmer wrote:

After the dawn, we took inventory of our supplies, and found that we could cook eggs (two dozen were on hand) and coffee. Those with shoes got water off Rock Creek, and the ladies fried eggs, canned potatoes, and we put the delicious hot mess on a slice of bread. Not everyone ate, but those who could were heartened....At last, one small orange and silver plane [piloted by Ralph Cooper] *swooped low, circled and waving its wings flew to the east toward the dam. We had been seen.*[57]

The next plane to reach the site came from Bozeman, only ninety miles away. Just before dawn, Gallatin County sheriff (as well as the civil defense director for the county) Don Skerritt, Bozeman radio executive William Merrick and flying service owner and pilot Al Newby departed Gallatin Field in a single-engine Cessna 172 four seater.

"The whole area around Hebgen Dam is a mess," the sheriff reported, in the first detailed description of the disaster area by an outsider. "A lot of tourists were trapped in the area when the roads were wiped out. A mountain slide has occurred below the dam. It appears that a whole mountain has collapsed. It's the biggest slide I have ever seen."

He next described a crack in the earth that ran for miles from the dam toward West Yellowstone. "It is six to ten feet wide, and has totally ruined

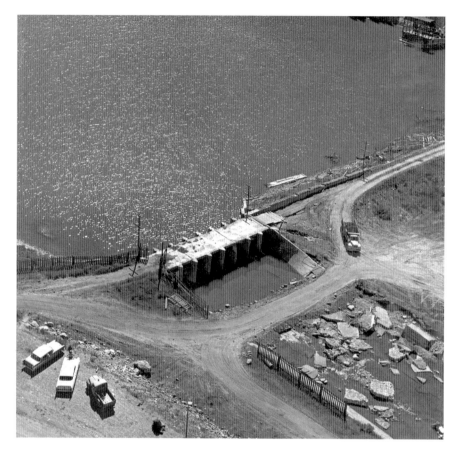

Despite being damaged by the quake, the earth-filled Hebgen Dam held. *U.S. Forest Service.*

roads, bridges, and summer homes. I saw one building which was split right in two by the fissures and both halves shoved apart. The damage is unbelievable, and many tourists are trapped in the area."[58]

Al made several passes over the canyon, and the three men frequently saw survivors waving to get their attention. Near the mouth of the canyon, a few campers seemed to be searching the rocks for bodies.

The plane then returned to Bozeman, where Sheriff Skerritt contacted Hugh Potter and Sheriff Brook and then turned to the thousand and one details related to coordinating with civil defense, the Forest Service, other police agencies and the Red Cross; monitoring helicopter flights; getting medical help to the injured; evacuating the canyon, searching for bodies; keeping curiosity seekers out of the area; and on and on.

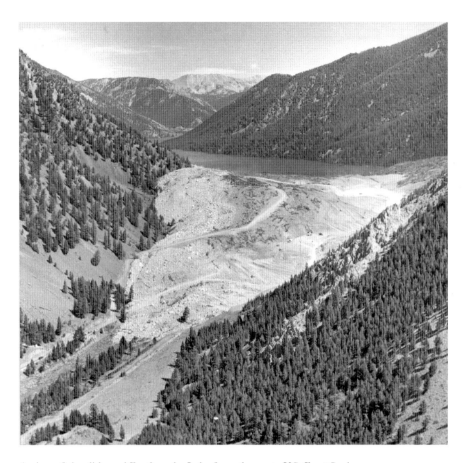

A view of the slide and Earthquake Lake from the west. *U.S. Forest Service.*

The quick and effective action of the Montana Highway Department and Mountain States Telephone facilitated and simplified all of these tasks. First, even though opening the roads was a gargantuan assignment given the extensive damage caused by the quake, the highway department went well beyond the call of duty. At 3:45 a.m., for example, highway maintenance man George Barrett noted: "Talked with Spike Naranche [of Naranche & Konda Contracting Company] and requested that he make arrangements to move his rubber tired equipment immediately to the site in order to start repairing road damage as soon as possible." By 8:00 a.m., repairs had begun at the crucial Duck Creek Junction; by 9:30 a.m., plans were being made to send bulldozers to the quake area to clear a temporary road that would allow those with undamaged cars to exit the canyon.[59]

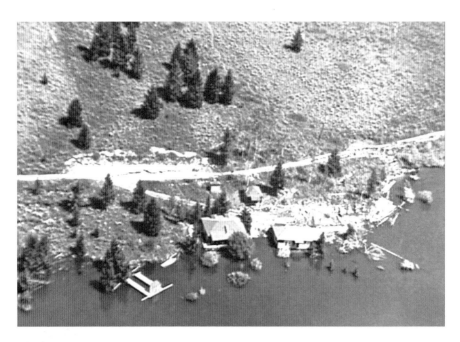

The sinking of Hebgen Lake's north shore dropped cabins and docks into the water. *U.S. Forest Service.*

Ray Greene (in the straw hat), Tootie (to his left) and others examine a note dropped by a plane. *U.S. Forest Service.*

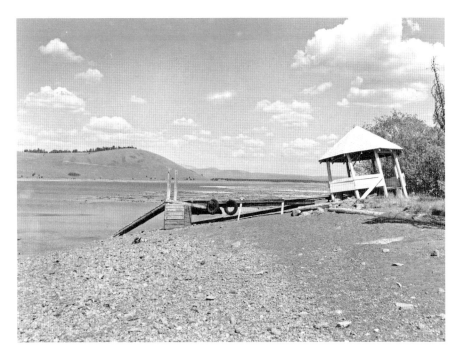

This 1960 photo shows one of several boat docks on the west shore of Hebgen Lake that were left high and dry by the quake. *National Archives, photo by W.W. Gordon.*

Second, Mountain States Telephone also sprang into action immediately. At 11:39 p.m. on August 17, two minutes after the quake struck, L.E. Johnson, Montana plant manager, got word that "the Bozeman–West Yellowstone long-distance circuits were in trouble." At 2:00 a.m. on Tuesday, after Johnson consulted with F.A. Pippy, Helena district plant manager, a two-man crew from the Bozeman plant "was dispatched southward toward West Yellowstone. The men were to call from various test points on the line and pass whatever information they were able to pick up." At 4:00 a.m., another crew of three men left for West Yellowstone. At 5:30 a.m., "Pippy and L.O. Epperly arranged to leave by special plane for West Yellowstone." At 6:30 a.m., crews working south reported that they had been able to get around several slides and that they were removing trees when possible.[60]

All of this was a portent of how a variety of departments and agencies would act proficiently in the coming hours to help those stranded in the canyon.

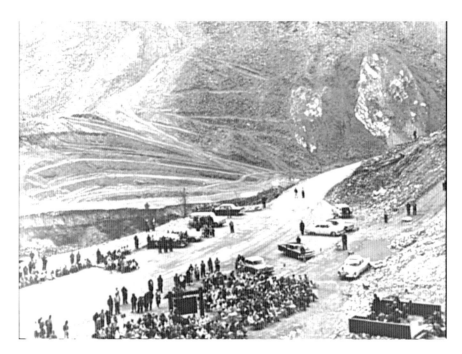

The dedication of the site took place on August 17, 1960, exactly one year after the earthquake. *U.S. Forest Service.*

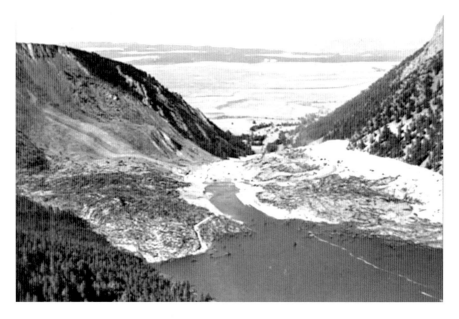

Water from Earthquake Lake begins flowing through the newly constructed spillway. *U.S. Forest Service.*

WHILE IT WAS EXPECTED that Montana Power, Mountain States Telephone, the Fish and Game Department, Gallatin County, the U.S. Forest Service and others would send planes to the scene of the catastrophe, one aerial odyssey came as a surprise to officials and a blessing to the seriously injured and their caretakers: the flight of Dr. Raymond G. Bayles, nurse Jane Winton and pilot Bob Winterowd.

Dr. Bayles was a fifty-six-year-old Bozeman physician with a second office in West Yellowstone, where he also owned the Stagecoach Inn. "When the first hard jolt of the earthquake struck," he said, "I was enjoying some much-needed sleep in my apartment in the Bozeman Hotel. After being jolted from bed, I immediately switched on the radio to catch any news, but at that time, it was too early for any reports."

He dressed and went down to the lobby, where most of the guests had gathered, some nervous and some frantic. After doing his best to calm people down, he tried to call West Yellowstone to check on his employees at the Stagecoach Inn, but the phone lines were down. For the next few hours, he listened to the radio and made calls to the Gallatin County Sheriff's Office, gradually learning of rumors that Hebgen Dam was leaking badly.

"At dawn, equipped with my medical bag, I chartered a plane from Flight Line Inc., piloted by Bob Winterowd, for the flight to West Yellowstone," he said. "We attempted to fly directly toward Ennis but encountered a severe thunderstorm and were forced to fly back and up the Gallatin Canyon and over the mountains, coming into the Madison at the lower end of the Canyon."

At this point, neither Dr. Bayles nor Bob had heard about the slide. "As the canyon came quickly into view, we were completely appalled," said Dr. Bayles. "The mountain on the south had fallen across the canyon. It was hard to comprehend the immensity of the slide and damage it inevitably had done."

Bob circled down and flew as low as possible. "The whole area seemed to be green, due to uprooted trees lying crisscrossed like matchsticks, except for the top part of the slide that had rolled up the opposite wall of the canyon like a giant ocean breaker."

Bob flew up and down the canyon. They saw the Ost/Frederick group "on the highest ground they could reach...desperately waving anything available to them to attract attention." Farther up the canyon, "there were a large group of people, cars, tents and campfires."

Clearly, any people in the immediate vicinity of the slide had been killed or injured. "The fate of the people completely trapped between Hebgen Dam and the slide, a distance of seven miles, was indeed precarious."

After thoroughly surveying the site, Bob and the doctor flew the short distance to West Yellowstone and landed there. Dr. Bayles asked Bob to wait there and caught a ride to the Stagecoach Inn. He found his employees huddled around a fire across the street from the inn. None of them had been injured. Someone said the inn had been damaged, but Dr. Bayles paid little attention to that. "I was more concerned with the sorry plight of the people trapped between the dam and the slide."

Turning to Jane Winton, the inn manager who was also a registered nurse, Dr. Bayles asked, "Are you willing to fly back to the slide area with me to render what aid we can?"

"Yes, it would be a relief," she answered.

They gathered additional medical supplies and drove slowly along the shattered highway to the airport.

"Are you willing to fly back to Hebgen Lake and attempt a landing?" the doctor asked Bob Winterowd.

"If you're willing, so am I," replied Bob.

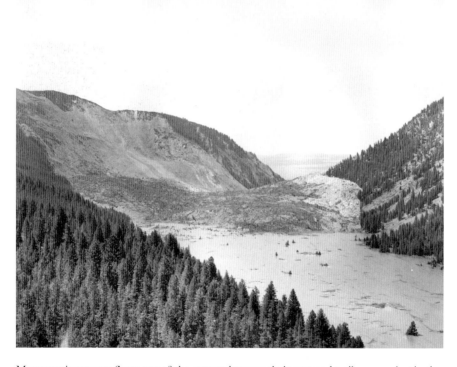

Many survivors were flown out of the canyon because their cars and trailers were lost in the flood. *U.S. Forest Service.*

Visitors at Earthquake Lake, July 1960. *National Archives, photo by Leland J. Prater.*

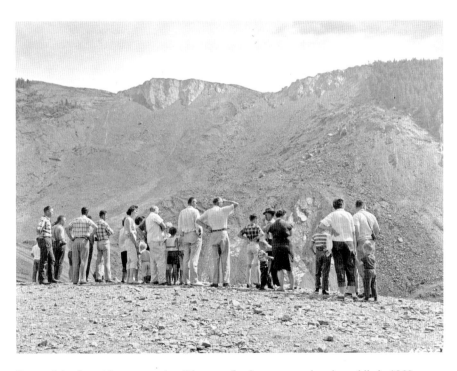

Some of the first visitors to see the slide area after it was opened to the public in 1960. *National Archives, photo by Don Fritts.*

Within minutes, they were flying toward Hebgen Lake. Bob found a good field to land in at the Watkins Creek Ranch, about two or three miles from the dam. "We walked about half a mile down the lake toward the dam through mud and debris thrown up by the tidal waves." There they found a group of people at the muddy new shore, at a spot that had been covered with deep water the previous night. Several of those present were dragging boats out of the water. "These people believed the dam was going out, and were reluctant to lend a boat. Finally, a young fellow, whose name I never learned, volunteered to take us across in his motorboat."

The doctor and Jane climbed in the boat; the young man started the outboard motor and began navigating the boat through the trees and shards and dead fish. Dr. Bayles and Jane looked out at the murky brown lake, tilted at an unreal angle that revealed just how much the landscape had shifted. The north shore had disappeared, the water now lapping at the roofs of cabins, covering the highway, and flowing through trees.

As they approached the dam, Jane was alarmed to see a crack in the concrete core.

"Keep watching that crack," Dr. Bayles said. "If it gets bigger, you know what will happen. If not, you'll have a great story to tell your grandchildren someday."[61]

The young pilot of the boat found a place near the dam to dock, and doctor and nurse forgot about their personal risk and turned to the mission that had brought them here: treating the injured.

6

"I WISH I COULD FIND MY CHILDREN"

Taking the back roads rather than the highway, Glen Stevens and his contingent reached Cliff Lake about 4:45 a.m. About that same time, wrote Martin Stryker, "a nice Japanese family, whose names we never received, drove my brothers to Ennis and then to Virginia City. I stayed with the bodies of Dad and Ethel, and soon after, a sheriff's deputy arrived after hearing the news from the evacuating cabin dwellers. He got in touch with a local rancher who had a heavy-duty winch that they used to move the boulder that had lodged on Dad and Ethel's tent."

Glen's account fills in some of the details. "There wasn't anything we could do," he said. "The boulder was too big to move, so we went down to the Shaw ranch and got Frank Shaw to take his four-by-four truck up and move the boulder."

The Shaw ranch was just a few miles north of Cliff Lake. After Glen and his three companions arrived there and explained the situation to Frank Shaw, who was eager to help, Glen and Dutch left and headed for the mouth of the canyon, only minutes farther north. Frank, Hector Baldwin and Gene Todd were soon joined by another local resident, Bill Buyam, and the four of them made their way to Cliff Lake and removed the boulder.

"The boulder had jumped the Forest Service dining table without disturbing our cookware and meal set-up and landed right on top of the tent," wrote Martin. "If the boulder had continued to roll, my brothers and I would surely have been killed."

Kathryn Stryker, mother of the Stryker boys, who endured long, tense hours of waiting before learning that all three had survived. *Photo courtesy of Martin Stryker.*

The family dog, which had slept in the car and was missing when Martin discovered the tragedy, had returned by this time. "At mid-day, we left the area in a pickup truck with all the belongings I could pack, the dog, and the bodies in the back of the truck," Martin wrote.

Frank Shaw drove for Virginia City, where Martin could join his brothers, John and Morgan, and where the bodies of Edgar and Ethel Stryker could be taken to the county morgue and then to a mortuary. John and Morgan, of course, had reached Virginia City several hours ahead of Martin, and the Red Cross immediately notified the boys' mother, Kathryn Stryker, that "her two boys were safe." It would be twenty-four hours before she learned that all three boys were OK. The delay was due to the phone lines' being overloaded in the hours after the quake. Kathryn was one of many relatives who waited anxiously for a day or longer to hear the status of their loved ones.[62]

IRENE BENNETT HAD ENDURED the long night and was thankful to see the sky finally brighten.

"When daylight dawned and I could see around me," she wrote, "I crawled, being unable to stand, down towards the riverbed. I repeatedly called. 'Pud, I'm here. Kids, it's Mom, where are you?' AT LAST, I heard an answer."

"Mom?"

It was Phil, Irene's sixteen-year-old son. He had seen the family's demolished car and was crawling toward it when he heard Irene calling. "Suddenly there was a huge roar," Phil later said, describing the slide. "I looked up and saw the mountain cascading down on us. Next thing, I was flying through the air. I landed in the water. It washed me a long

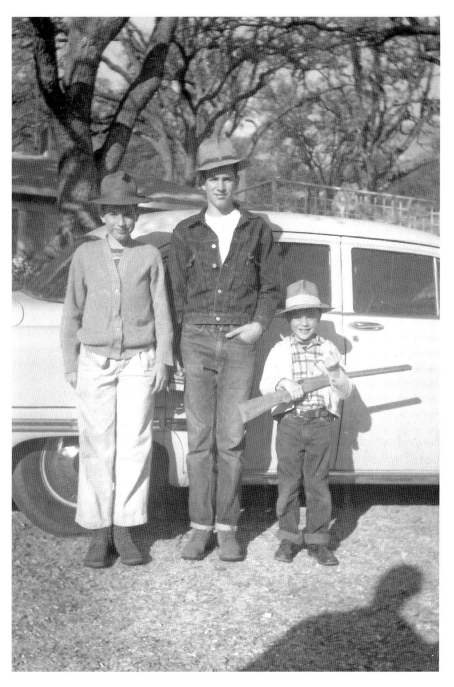

The Stryker boys, late 1950s. *From left to right*: John, Martin and Morgan. *Photo courtesy of Martin Stryker.*

ways downstream. Boulders and trees kept hitting me." Phil's leg had been mangled as he was thrown into the river and across the rocks, but he had crawled to a clump of trees and dug into the mud for warmth. He lay awake all night, preparing himself for the water he felt certain would engulf him.

"By the sound of our voices we reached each other down in the empty riverbed," wrote Irene. "Seeing him made my heart almost cease beating. His leg looked like a letter S dragging behind him as he pulled himself towards me with blood flowing from cuts behind his ear and the top of his head."

They heard the distinct drone of a plane, waited and then saw it directly overhead. Both of them raised their arms and waved but feared they could not have been seen. Now they resumed their long wait, this time together. "After a seeming eternity we began to hear voices," wrote Irene. "We called, 'Help! We're over here!'"

They heard the sound of someone scrambling toward them across the rocky riverbed. Then two men came into view. They were local rancher Morris Staggers and camper Lloyd Verlanic.

"Oh, thank God," said Irene, shivering. "I've been crawling and praying all night. My children, oh my God, my children, I wish I could find my children."

Lloyd leaned down to comfort Irene. Then he called out, "Over here—they're alive!"

A minute later, a woman came across the rocks and the pockets of water carrying blankets. She draped one over Phil and one over Irene. "Wonderful not only for warmth but the embarrassment of being nude," wrote Irene.

"My name's Betty Jensen," the woman said to Irene. "We don't dare move you, but help is coming."

"Please find the rest of our family" said Irene. "My husband and three children are here somewhere." She described Pud and her children to Betty.

Within minutes, however, one of the rescuers found Pud's body about fifty feet from where Irene and Phil had been discovered. He called others, and the situation was so obvious that Betty could not hide the truth from Irene.

"The lady who brought blankets [Betty] gave me the sorrowful news," wrote Irene. "Tears engulfed me; my heart throbbed, knowing I'd lost Pud and our happy life together had ended."

"Here, dear," said Betty, handing Irene a handkerchief, "use this and go ahead and cry."

Irene wrote of Betty, whose name never appeared in the newspapers: "She stayed with me through my first overpowering grief."

The "help" mentioned by Betty arrived minutes later in the form of Glen, Dutch and another local rancher, Garnett Oliffe.

"We found Irene and Phil Bennett lying in the rocky stream bed," said Glen. "Both of them were bruised and bashed."

Hearing there were injured victims at the edge of the slide, Garnett had retrieved a wood-frame canvas cot from a bunkhouse and brought it with him. It was just what they needed, and Glen and Dutch and Garnett lifted Irene onto the cot.

"As we struggled through the slippery muck," Glen remembered, "she kept apologizing for causing us so much trouble." He added: "Their torn hands gave the story of the agonizing effort these crippled survivors had made to drag themselves together over the rocky stream bed."

They were halfway across the riverbed when Ralph Cooper's Fish and Game plane flew overhead. "Look," Irene whispered, "there is that airplane coming back again. I waved at him before."

Seeing the condition of Irene and Phil—and also seeing the plane—had sparked a fresh idea for Glen. "Dutch," he said, "will you take the patrol car

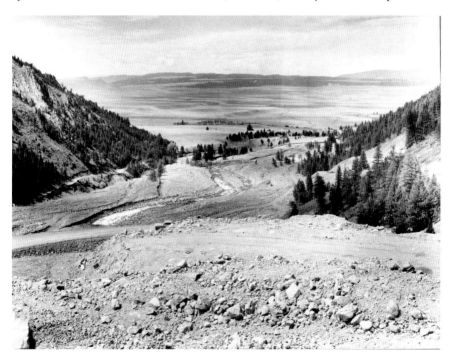

A view of the riverbed and western edge of the slide, where the Bennetts and Stowes were camped. *National Archives, photo by Leland J. Prater.*

down the road and out of the canyon to radio that plane for a doctor to help Mrs. Bennett and her son."

"Right away," said Dutch, getting the keys from Glen.

"There was a young couple from Utah camped next to us," Irene said. "Please try to find them, too."

"We will," said Glen, stepping in a two-foot-deep pocket of water and almost falling.

"I'm sorry I'm so much trouble," said Irene.

"You're no trouble," said Glen. "We just wish we had gotten here sooner."

They got Irene settled in the back of Garnett's pickup and didn't want to disturb her by moving her off the cot. "Morris Staggers…showed up with an old iron bedstead, older than anyone there, and heavier too. I'll never forget the struggle we had carrying the Bennett boy across on it."

Ralph Cooper got the request to help and landed at the Ennis airport, where Dr. Losee was waiting. "I hated flying," said the doctor. "The pilot asked, 'Are you ready? Now is as good a time as any.' And he took off without my answer."

Ralph followed the highway along the east side of the Madison River. "We landed on the two-lane highway at the mouth of the Madison River Canyon north of the Missouri Flats," wrote Dr. Losee. "The real problem at hand was a young man of sixteen or seventeen lying in the back of a pickup truck with a compound fracture of his tibia. Accompanying him was his mother who had also been battered and traumatized."

The doctor had brought supplies with him and got busy treating Irene and Phil. He did everything he could and then said, "These patients require immediate hospitalization."

A local resident named Jerry Morgan had joined the group and got in the back of Garnette's pickup to hold transfusion bottles for Irene and Phil. Doctor Losee drove the pickup, and Morris followed in his truck.

"I didn't want anyone to drive me," said Dr. Losee. "I wanted to control that truck in case there was a flood of water." With the patients "bouncing in the truck bed," he dodged rocks and boulders in the road, driving on the highway shoulder when needed. "I drove quite smartly, alone in the cab," he wrote. "There was much looking backward at every opportunity. There was much assessment of possible off-highway escapes to higher land when the flood came roaring down from behind."

There was no flood.

Jerry Morgan reported that Dr. Losee "made the forty-mile dash at a speed which left him staggering." When Irene and Phil finally reached Ennis around 10:00 a.m., they were the first earthquake victims to be hospitalized.

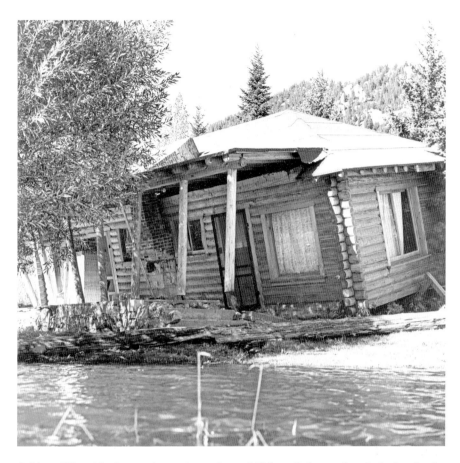

Cabin at Hilgard Lodge, on the northeast shore of Hebgen Lake, was knocked askew by the tidal waves that surged across the lake. *U.S. Geological Survey.*

Working with men from the Fish and Game Department, Glen and his companions found all the people Irene had mentioned except one—the young woman from Utah. "Like Mrs. Bennett and her son," said Glen, "all of these bodies had been stripped of their clothing and showed the effects of being beat to hell by wind and water. The coroner [in Virginia City] said all five of them died by drowning."

Reflecting on the experience, Glen added, "I just don't care to go through any more mornings like that."[63]

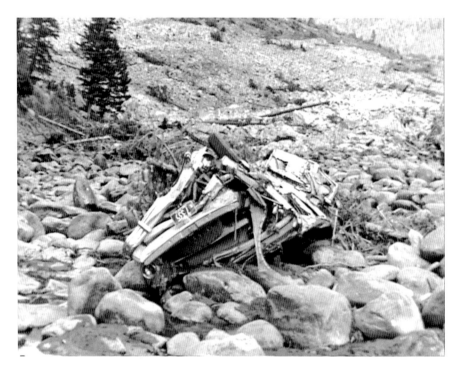

The Bennett car was tossed amid the mass of boulders and felled trees. *U.S. Forest Service.*

ABOUT THE SAME TIME that Lloyd Veranlic and Betty Jensen first reached Irene and Phil, Robert Burley, Frank Martin and Fred Donegan had finally obtained a boat. The scene at the dam was chaotic, with cars, trucks and trailers parked everywhere, many people asking questions, some injured seeking help and no one sure if the dam would hold. Robert asked about the foreman of the dam and was told that his name was George Hungerford and he had gone down the canyon to check on the slide. When George returned, Robert and the others told him about the Maults and asked if they could get a boat. Yes, he said, he had a twelve-foot aluminum rowboat.

Knowing how important every minute was to the Maults, the three rescuers tried to hurry, but everything seemed to go in slow motion. A shed had to be unlocked, various items moved out of the way, the boat pulled out of the shed, the Montana Power truck found, drivers asked to move cars, the truck hitched up to the trailer. Finally, they were on their way, but the drive itself was agonizingly slow, with cars on the highway going in both directions and boulders and damaged road slowing them to a crawl at every turn.

Daylight had come, and the Maults were still holding fast to the tree they had first grasped more than six hours earlier. "I didn't think we were going to be saved," said Lillian. "They didn't come and I knew they weren't coming."

Robert, Frank and Fred at last had reached Eagle Creek and were making good time; then they saw how far the water had come and that they were still a good distance from Rock Creek Campground. There was nothing to do but launch the boat.

They got the boat unhooked, Robert and Frank got in the boat and Fred turned the truck around to face the dam. Once again, Fred waited in the vehicle. Soon he would have to drive farther toward the dam and then farther, the water rising and rising. "We put the boat in the water and headed for the middle of the river," said Robert. "The debris was so bad I could understand why we almost lost our fellow rescuer the night before." As they rowed, they saw that fellow rescuer, David Thomas, who had retreated to higher ground but was still encouraging the Maults.

"We worked our way through the debris and located the people clinging to a tree," said Robert.

This was the first time either Robert or Frank had actually seen the Maults, and they were surprised to find an elderly man and his wife. "They were exhausted and just about frozen by the cold water," Robert continued. "I believe if we had gotten there fifteen minutes later, they would have been gone."

"She had given up and was ready for the grave," said Frank, "but he hung onto her with one hand and the tree with the other. They were just about out of the tree."

"They came for us in a boat and got there just in time," said Grover. "If they'd been another ten minutes I couldn't have held on."

Robert and Frank somehow got first Lillian and then Grover into the boat without swamping it—a challenging task because neither of them could move their legs. "We felt like we were literally frozen," said Grover.

"We took the old couple to shore immediately and built a fire to warm them," wrote Robert. "It was then that I could see for the first time the avalanche. There was a whole new mountain possibly three hundred feet high across the valley."

In the daylight, it was also now clear that when they were liberated from the tree, the Maults had been about thirty feet above the ground level of the campground. ("I thought I'd have to climb all eighty feet of that pine," Grover would tell a writer from *Life* magazine the next day. "And I could have done it, too.")

Grover and Lillian Mault recovering at Bozeman's Deaconess Hospital. *Gallatin History Museum, Bozeman, Montana.*

Robert, Frank and Fred wrapped the Maults in blankets and headed for the dam. Grover and Lillian were still shivering, unable to talk or even move. They began to revive by the time they reached the dam and wanted to stand near the warmth of a fire there. But they had barely started when Grover collapsed.

Right: By Tuesday night, August 18, 1959, newspapers across the United States were running front-page stories about the disaster. *U.S. Forest Service.*

Below: At Culligan's ranch, caretakers John and Doris Russell and their children barely escaped a living place that had virtually trapped them. *U.S. Geological Survey.*

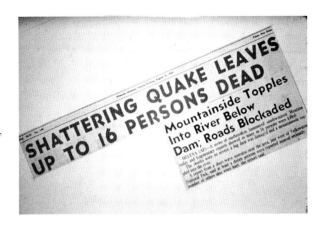

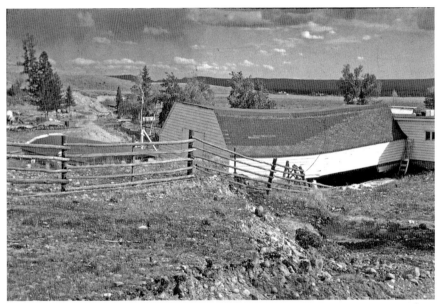

Tootie examined the Maults and found them in much better condition than she expected. They were suffering from shock and exposure but otherwise seemed OK. She gave them a warm drink and had them wrapped in sleeping bags and placed in the back of a station wagon.

Within months, the unassuming couple would be telling their incredible story to Art Linkletter in a nationally televised interview.[64]

"GEARING UP FOR A RESCUE"

Routed out of bed at about 2:45 AM," Ennis forest ranger Neil Howarth noted in his log on August 18. "Evacuated family and got truck 702 with radio." He immediately contacted his superiors in Dillon to let them know about the earthquake and the evacuation of Ennis. By 3:15 a.m., Neil was joined by fellow ranger Blaine Tennis; they dispatched a truck with a mobile radio to the Virginia City hill as a relay. Then the two rangers got busy:

> *Contacted mayor of town and reported what we had available which we could place at his disposal.*
>
> *Contacted Charlie Raper, County Coroner, to see about getting two known dead out of Cliff Lake. Because of conflicting reports and rumors, we decided to hold until daylight.*
>
> *Tennis and I discussed possibility of smokejumpers, organize from Missoula, observation flight.*
>
> *Called Dillon and ordered an observation plane to be in Ennis at daylight so we could find out and notify Ennis just what the situation was.*

Blaine manned the radio and telephone while Neil made the flight and offered one of the first reports that "Hebgen Dam was holding and appeared solid with the only water going over spillway and through tubes."

Not long after Neil returned to Ennis, he and Blaine followed up on their initial discussion and "ordered out smokejumpers who had advanced training in first-aid to be dropped in Madison Canyon." The well-trained

rangers ordered helicopters at the same time and also arranged for station wagons well supplied with blankets to be standing by at the makeshift heliport above Kirby's Ranch.[65]

At Missoula, two hundred miles northwest of the disaster area, smokejumpers got notice.

"I was called out to the Aerial Fire Depot in the early morning of that day assuming it was going to be a fire mission" recalled smokejumper Bob Nicol, "but the base was gearing up for a rescue. The plan was to load the airplane with emergency medical technicians, but since most jumpers were out on fires, all available overhead were suited up."

Seven other jumpers scrambled out of their bunks about the same time as Bob and grabbed their jumpsuits, boots, helmets, gloves and personal gear

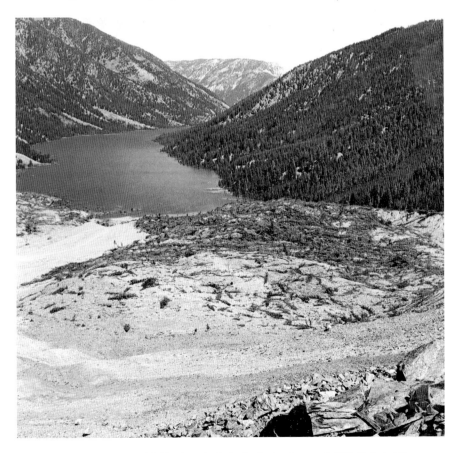

Trees strewn on the slide, with Earthquake Lake in the background. *U.S. Geological Survey.*

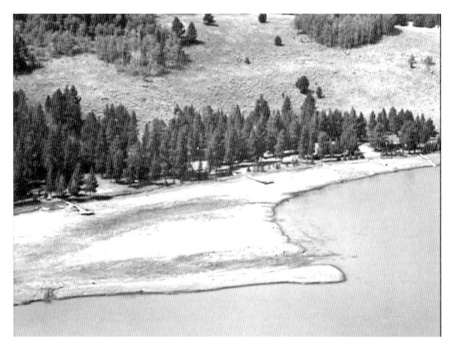

At certain points on the west shore, Hebgen Lake had receded dramatically. *U.S. Forest Service.*

Ranchers throughout the region saw damage and mishaps of all sorts. *U.S. Geological Survey.*

bags and then rushed to organize their main chutes, reserve chutes, first-aid kits and various odds and ends that included maps and radios. Meanwhile, the pilot and others hurried to prepare the Douglas DC-2 two-engine plane that would transport the jumpers and two spotters and all their equipment and supplies to Madison Canyon.

Another Missoula resident who got an early morning call as a result of Neil and Blaine's planning was helicopter pilot Fred Gerlach, a professor of Forestry at the University of Montana who worked summers for the Johnson Flying Service. At 7:00 a.m., someone at Johnson's called Fred and informed him of his mission. He dressed and drove quickly to the airport, knowing the Bell 47G was virtually ready to go. (The Bell 47 was a tremendously popular and highly reliable helicopter that had been the first chopper certified for civilian use and the first to transport aU.S.president when one flew President Eisenhower from the White House to an airport in 1957.)

Rescues were nothing new to Fred. Only two weeks earlier, he had rescued twenty-year-old smokejumper John Benton, who had injured his back fighting a fire at Holland Lake, northeast of Missoula. Hot, thin mountain air over Missoula had made flying risky, and Fred circled the city while bright orange streamers were placed on power lines to reveal their position as well as wind direction. Then Fred had set down safely near the front entrance to a hospital as police blocked the street from vehicles and an estimated 150 onlookers.

Now, after running through a series of checks with another Johnson employee and radioing his status to his home base, Hugh Potter and others, Fred took off around 8:00 a.m. It would take him a little over two hours to get to the quake site.[66]

DURING THE NIGHT, several campers at Halford's Camp—about two miles below the dam and four miles above the slide—had formed a rescue party to help bring the injured out of the slide area to Refuge Point. Among the group was Gerald McFarland, a newsman from Oregon. "We brought about twenty people out and made them as comfortable as possible," he wrote. A few hours after daylight, he continued, "we organized a volunteer party to return to Halford's Camp for food and medical supplies. We were all jittery. We thought it might be days before we could escape the rubble." The group included Gerald, "I.K. Saltzman, who lives near Canton, Ohio, Terry Owen and his son Jack, from Riverside, California, and Hank Powers, of Twin Falls, Idaho. We

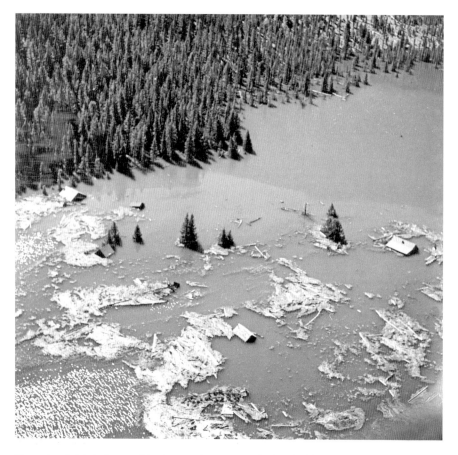

Houses and debris float amid submerged trees near the head of Earthquake Lake, August 1959. *U.S. Geological Survey.*

made two trips into the camp and brought back food and medicine. This greatly improved the supply problem and helped the injured."[67]

ABOUT THIS SAME TIME, word spread through the crowd at the dam that a doctor had arrived, news that brought gasps of relief from some but murmurs of skepticism from others. The two well-dressed men who had reached the dam a half-hour earlier in a motorboat and were thought to be doctors had turned out to be Montana Power officials checking on the dam. This time, though, the two people stepping out of a boat were a doctor and nurse with medical supplies.

"A nurse, Mildred Greene, met us at the other end of the dam," wrote Dr. Bayles. Tootie, who had arranged for several victims to be transported

from Refuge Point to the dam, explained the situation to the doctor and Jane Winton and told them Frances Donegan had stayed with the injured still at Refuge Point. "She [Tootie] had gathered all the more seriously injured in the area just along the highway end of the dam," said Dr. Bayles. This group of fifteen seriously injured patients included the following people: Ray and Myrtle Painter; Margaret and Verona Holmes; Tony, Germaine and Bonnie Schreiber; Warren and Esther Steele; Joseph and Ruby Armstrong; Clarence and Olive Scott; and Grover and Lillian Mault. Dr. Bayles described the specific injuries of several of them:

> *A woman whose left arm was nearly severed in two places; she had suffered a crushed chest and was in severe shock* [Myrtle Painter];
>
> *a woman who had suffered three deep body wounds and a severe blow to the head* [Margaret Holmes];
>
> *a man with painful internal injuries, a broken collar bone and severe lacerations* [Clarence Scott];
>
> *a man with deep lacerations over 90 percent of his legs* [Ray Painter];
>
> *a girl with a crushed ankle* [Verona Holmes];
>
> *a woman with a broken vertebra* [Esther Steele];
>
> *a small child with a gash over her eye, which at the hospital, required thirty-two stitches to close* [Bonnie Schreiber].

Dr. Bayles, Jane and Tootie went from patient to patient, diagnosing injuries, applying new bandages, administering the medications brought for pain and shock and reassuring patients and concerned family members that more help was on the way. They also determined which victims should be flown out first and tagged them appropriately. The first four scheduled for evacuation were the Painters, Margaret Holmes and Clarence Scott.

Dr. Bayles was impressed by the first aid given by Tootie and Frances Donegan, saying they did "wonderful work in the absence of drugs, medications and even bandages." They had also kept the victims "all under control and calm and quiet."

The doctor and Jane spent about an hour and a half at the dam and did everything they could. "The injured couldn't be taken out by boat," he said, "since they were too badly hurt to be transported that way, and the lake was too dangerous." He told Tootie and others at the dam that he would return to West Yellowstone and coordinate air rescue from the dam and Refuge Point to the West Yellowstone Airport by helicopter and from the West Yellowstone Airport to the Deaconess Hospital in Bozeman by plane.

"While we had been making our hazardous crossing of the lake, above the shaky dam," wrote Dr. Bayles, "the old World War II slogan, 'Is this trip really necessary?' kept popping into my head. As it turned out, it was, and I shall always be glad we made it."[68]

The doctor and Jane had barely left when a plane dropped a message: "Copters will be in the area about 11 AM." The plane delivering the note was one of swarm of aircraft—there seemed to be a constant stream of them virtually strafing the canyon. The folks at the dam and Refuge Point would later find out that most of these planes were carrying reporters or sightseers.

Leo Carper, a Billings photographer, was one of those in a press plane. "At the [West Yellowstone] airfield there was a lot of activity—too much, it seemed to me," he said. "Planes were flying around every which way at all levels and they were coming and going so fast I couldn't keep track of them. They finally closed the strip because of the traffic and I guess it was a good thing. It seemed real hazardous to me."[69]

The great majority of planes buzzing around the canyon appeared to hold four or five passengers at most, but around 10:30 a.m., a distinctly larger, two-engine plane approached, one with an orange nose and tail and white fuselage with *FIRE* painted on the nose in white letters and *US Forest Service* on the fuselage in black letters. A door at the rear of the fuselage was missing.

There were several smaller planes nearby, and for a moment it looked like there might be a collision, but the Forest Service pilot weaved his way expertly through the chaos.

"It looked like half the mountain on the south side of the canyon had been cut in half and dumped into the river," said Bob Nicol. The jumpers could see that the highway disappeared under the slide and that many people were trapped between the slide and Hebgen Lake. "Several dust plumes were coming off the main slide," Bob added.

There were eleven men in the plane, including pilot Milton "Cookie" Callaway, spotters Joe Roemer and Randy Hurst and two four-man teams: foreman Al Hammond, squad leader Dick Tracy and jumpers Lowell Hansen and Jim Burleigh in the first team and foreman Andy Andersen, squad leader Bob Nicol and jumpers Pat Scheid and Bill McLaughlin in the second.

"We made a couple passes up and down the canyon trying to sort things out," said Bob.

Joe and Randy dropped a couple drift streamers to check drift direction and velocity.

"We got word that the Hebgen Dam had been cracked and could break at any time," said Bob. "Hammond said we'd better get those people to higher ground as quickly as possible."

Seeing large groups of survivors at the dam and also on the rise farther downstream, Joe and Randy decided to "split the load." Standing near the door, Joe signaled two men from each team to get ready. Cookie leveled off at about 1,500 feet above ground level, flew over part of Hebgen Lake, headed for the dam and cut his air speed. Joe checked the static line to make sure the jumpers were hooked up properly, with Randy checking air speed and topography at the same time. Then Joe signaled for Cookie to cut the air speed even further to prevent wind gusts from hitting the jumpers. Next, Joe slapped Al and Jim on the back, sending them out of the plane toward a landing spot near the dam. Then he waited until the plane approached Refuge Point and slapped the backs of Andy and Pat, sending them out.

Cookie banked in a wide loop and made another pass over the canyon; Joe and Randy repeated the same series of checks and signals, this time dispatching Dick and Lowell to the dam and Bob and Bill to Refuge Point. On the ground, all eyes were on the jumpers and their red-and-white chutes, swinging slightly as they drifted downward.

"The air was kind of rough, and it had started to rain," Bob said. "I was holding into the wind but was going downhill and backward a lot faster than I wanted to. There were some real impressive parachute landing falls made right among the rescuees that day."

Bob reached the ground safely, got free of the chute and shouted, "Bob—OK!" Within seconds, he heard Bill call out, "Bill—OK!" Soon, he saw that Andy and Pat had also landed safely. That was good; it hadn't been an easy jump. Just then, several people ran up to Bob and asked if he was OK. "Kind of ironic," he said.

The jumpers found a good spot for supplies to be dropped and radioed the plane. The first team was doing the same. Al Hammond met Tootie and consulted with her. At her recommendation, he radioed a request for blood plasma.

"The air in that canyon was full of little airplanes, mostly news media and sightseers, I suppose," said Bob. "There was probably some officialdom up there, but they had no radio contact or control of any kind. Cookie told me later that trying to drop cargo in that sort of deal was something he didn't want to do ever again."

Despite that, the cargo chute floated right to the target with a load that included medical supplies and food and water.

Like most of the others, Anita Painter Thon was surprised but thrilled when she saw the smokejumpers parachuting in: "We felt we had more angels that had been sent to help us…[and] were relieved that they had come and were setting up a rescue operation." Several men and kids ran to see what was inside the crates dropped from the plane, but, wrote Anita, "my sisters and I couldn't get excited about anything because we were so worried about our parents." None of the three would have anything to eat the entire day.[70]

"As the day wore on," wrote Florence Mander, "with planes buzzing us continually, gusts of wind and squalls of rain seemed to make the tremors greater and the mountains shake until it seemed they were going to shimmy themselves down." Several at Refuge Point voiced the opinion "that the planes were going to shake the whole area down." But there was one plane they were happy to see: "Everyone was grateful to the boys who parachuted in with medical aid and food and above all pure water. By now we were drinking water that was muddy." The plane had also dropped canned beans, sweet rolls and coffee.[71]

"We found a lot of hurt people," Bob said. "There was a lot of confusion, too, but folks were helping each other as best they could and had mostly done what could be done at that point."

Two of the original smokejumpers, Bob Nicol (left) and Al Hammond, at Refuge Point in 1999. *Photo courtesy of Bob Nicol.*

The rain had come up again, and "a couple of ladies asked 'Big Andy' if they could use his parachute for a tent. He couldn't refuse, of course, but was not too happy when later he saw they had cut off all the lines right at the skirt."

The jumpers administered some first aid and then tried to get all the campers to move to higher ground. "That was the hard part," said Bob. "They just didn't want to leave their vehicles, their tents or any belongings down by the river. We got most of them moved up a ways but not near far enough as far as I was concerned."

The jumpers searched for survivors and victims along the river and the rapidly rising lake. "We looked in vehicles, campers and trailers and took the license plates off everything that was or would be under water," reported Bob. "We continued searching until later the following day when most of us were demobed [demobilized] back to Missoula. Al Hammond stayed on to help explain things to the fact-finding officials."[72]

EARLIER THAT MORNING, after hearing the National Warning System disaster message, the Fourth Air Force Headquarters at Hamilton Air Force Base in California had offered its search-and-rescue resources to Montana governor J. Hugo Aronson and Civil Defense director Hugh Potter. Not long after that, fully manned and equipped rescue squadrons and support groups, in both planes and helicopters, were on their way to West Yellowstone from the following bases:

- Hamilton Air Force Base, California: the Forty-First Air Rescue Squadron;
- Hill Air Force Base, Utah: 2849th Air Base Wing Rescue;
- Stead Air Force Base, Nevada: 3638th Flying Training Squadron;
- Malmstrom Air Force Base, Montana: 4061st Support Group.

Montana Aeronautics Commission personnel were quickly dispatched to the West Yellowstone Airport to handle air traffic control and related services.

The Salvation Army and Red Cross also swung into action. The Salvation Army and St. Vincent DePaul Society of Butte shipped clothing and blankets to Ennis and Virginia City. Meanwhile, Major Ernest Orchard, Lieutenant Nels Nelson and others of the Billings Salvation Army headed to West Yellowstone in trucks and canteen station wagons to deliver blankets, mattresses and other items and to serve meals. Workers from Montana,

Wyoming and Idaho were also on their way, and a shortwave radio mobile truck had also been dispatched to West Yellowstone.[73]

The National Red Cross ordered staff members into key Montana locations as soon as the scope of the disaster became apparent. Workers were sent to Sheridan, Helena and West Yellowstone. By Tuesday afternoon, a Red Cross canteen had been set up at the West Yellowstone Airport. All operations in the state, however, were centered at the Gallatin County Chapter in Bozeman because it was the most practical central point for the coordination of welfare inquiries and the coordination of disaster relief. Ruth Berg, of the Bozeman office, was deeply involved in all aspects of earthquake relief and worked closely with Sheriff Skerritt's office.[74]

Tuesday morning, when Sheriff Skerritt called the Deaconess Hospital in Bozeman and requested help at West Yellowstone, hospital superintendent Richard Lubben and six nurses—Sue Barclay, LaVonne Lindgren, Karlene Topel, Mrs. Carl Rognlie, Ann Blackhall and Marilee Heffelfinger—volunteered to go. The nurses were driven in Highway Patrol cars while Richard and Harold Miller drove pickups filled with medical

Officials and volunteers at the West Yellowstone Airport prepare to receive injured victims. *U.S. Forest Service.*

supplies, blankets, stretchers and other equipment. At West Yellowstone, this group met Dr. R.C. Quinn, a Hollister, California physician who had flown in to assist with the treatment of earthquake victims. This group set up a first-aid station at a hangar at the West Yellowstone Airport to care for victims arriving from the quake area and awaiting transfer to Bozeman. Bales of hay were moved into the hangar and covered with blankets and sleeping bags to serve as beds. Richard later said that with the exception of plasma, the supplies brought from Bozeman were adequate for the treatment of the patients they saw.[75]

Dr. Bayles, of course, was also active at the hangar/field hospital, coordinating with Dr. Quinn and the nurses and also consulting with the Johnson Flying Service DC-3 pilots who would fly the patients to Bozeman: Ken Roth, Swede Nelson, Bob Schellinger and Mark Starr.

On short notice, an incredible number and variety of people had combined their talents to help the victims in any way possible, and the efforts at West Yellowstone were particularly timely because around 11:30 a.m., about an hour after the smokejumpers had parachuted in, an air force helicopter from Utah's Hill Air Force Base appeared over the canyon. It was a Piasecki H-21 Workhorse, designed specifically for high-altitude rescues. The campers gathered at the dam clapped and cheered and smiled at one another as the big chopper hovered briefly and then set down on a flat, open spot as directed by Al Hammond.

The three crew members—Captain P.A. Reary and Lieutenants Lantz and May, all in flight suits and helmets—exited the helicopter to consult with Al Hammond and Tootie. The five of them talked for several minutes. Then Al motioned to some men standing near the vehicles, and six of them gently lifted Myrtle Painter out of the fishing trailer onto a makeshift stretcher and carried her toward the helicopter. A hush came over the crowd, which remained reverent as other litter bearers followed, transporting Ray Painter, then Margaret Holmes and finally Clarence Scott to the H-21 aircraft. Mangled by wind, rocks and water, these four, who had required immediate hospitalization the instant they were injured, had waited an unremitting twelve hours simply to be placed in an ambulance. It would be another two hours before they actually reached a hospital.

Ray and Myrtle, who had suffered so intensely all night, were symbolically being rescued by friends and neighbors because they knew Hill Air Force Base well; Ray had worked there as an aircraft mechanic during World War II.

Five and then ten minutes passed as the crew members got their patients settled, presumably securing them, hanging plasma bottles, checking vital

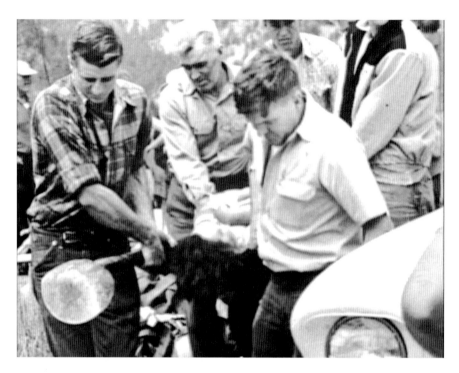

Volunteers at the dam carry Myrtle Painter to the air force helicopter. *U.S. Forest Service.*

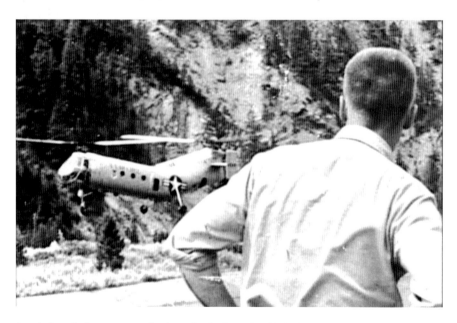

An air force helicopter near the dam. On its first trip, this helicopter evacuated Ray and Myrtle Painter, Margaret Holmes and Clarence Scott to West Yellowstone. *U.S. Forest Service.*

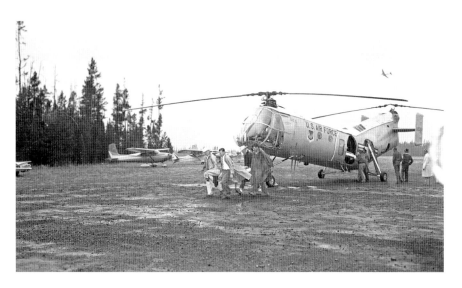

The injured victims from Refuge Point begin arriving at the West Yellowstone Airport. *Utah Historical Society, photo by the* Salt Lake Tribune *(this and all other* Tribune *photos taken by either Earl Conrad or Carl Hayden).*

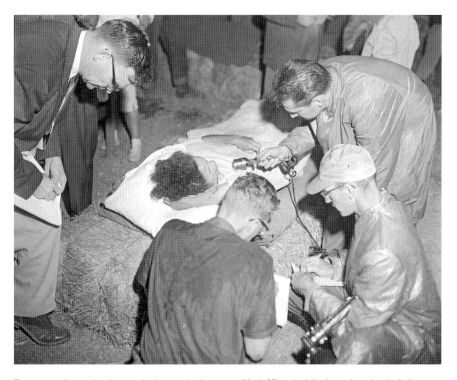

Reporters interviewing a victim at the hangar. *Utah Historical Society, photo by the* Salt Lake Tribune.

signs and so on. The minutes dragged on. Then a crew member stepped outside and examined the helicopter itself. More minutes passed. Then the two huge rotor blades finally started, turning quite slowly at first, taking forever to speed up. Eventually, they turned into a blur and then seemed to reverse direction, one way then the other, as the chopping clamor and unnatural wind kicked in with force. All this and the crew member was still outside. How long would it take to get these poor people to the hospital?

Finally the crew member opened the door and disappeared, but it was hardly a surprise that the copter sat for several more minutes. The crowd was moving and talking now, and someone called the helicopter "a flying banana."

When it finally came, the takeoff was nothing like what viewers of the TV show *Whirlybirds* saw, with small, agile helicopters rapidly ascending upward. Instead, the awkward, lopsided chopper rose several feet off the ground, hovered briefly and then flew forward, much more like a plane than a helicopter, cleared the trees ahead and continued elevating gradually but surely. Then it was gone.[76]

Would all four of the patients now safely in the helicopter survive? Would any of them?

8

"THE PRECIOUS JOURNEY OUT"

Newspaper subscribers across the United States had learned about the earthquake by glancing at their Tuesday morning paper. The front-page headline in the *Salt Lake Tribune* was typical: "Quake Jolts Western States."

The first three sentences covered the key points of what had been known when the copy went to press within a few hours of the quake:

> *An earthquake late Monday rocked a six-state area of the Intermountain Region and Pacific Northwest, trapped an auto in Yellowstone National Park, and reportedly cracked Hebgen Dam at West Yellowstone, Mont. Civil defense radio networks reported that an unknown number of persons in West Yellowstone were injured as motels collapsed. The Union Pacific station was crumbled and the injured were being taken to Ashton, Idaho, for treatment.* [77]

Evening papers for August 18 would tell a much different story.

DR. BAYLES HAD BEEN waiting at the West Yellowstone Airport when the H-21 Workhorse touched down. "The helicopter flew the first load of injured to the West Yellowstone airport," he wrote, "where they were immediately loaded onto the floor of a converted B18 and flown to Bozeman."

Despite the best efforts of the emergency personnel, however, few things that day happened "immediately." Given the chaotic circumstances of the situation and the fact that various agencies were simply not able to coordinate

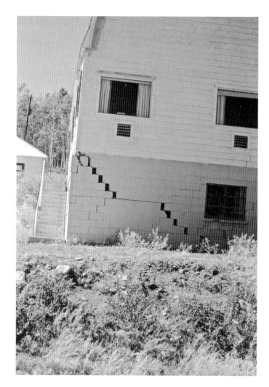

Left: The crack in one of Culligan's cement block foundations revealed the path of the main fault. *U.S. Geological Survey*.

Below: Depending on their location, Hebgen Lake docks were left high and dry or, like this one on the northeastern shore, low and wet. *U.S. Geological Survey*.

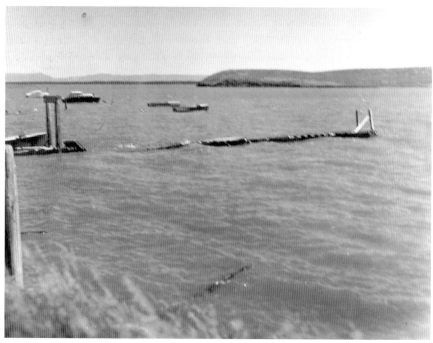

all of their services among themselves, delays were inevitable. The Painters, for example, were not taken directly from the helicopter to the plane, but waited in the hangar for an unknown period of time—at least long enough for a *Deseret News* reporter to interview Ray. "Mr. Painter told his story here after the helicopter had set down and he and his wife were waiting to be taken to another plane for transfer to a hospital at Bozeman," the reporter wrote at the West Yellowstone Airport. Anita Painter Thon indicated that her parents had a long wait in the hangar.

Although the departure time is unknown, it is clear that Dr. Bayles and one or two nurses accompanied the Painters, Mrs. Holmes and Mr. Scott on the fifteen-minute flight to Bozeman (which was 76 miles away by plane and 105 miles by car). Whether the patients then reached Deaconess Hospital by car or by helicopter is also unknown. Regardless, Dr. Bayles then returned to the Bozeman Airport and boarded the same plane for the trip back to West Yellowstone.

Mrs. Holmes and Mrs. Painter were both scheduled for immediate surgery.[78]

"Around 11 AM, the first helicopter landed at the dam and took four injured out," wrote Gerald L. McFarland. "From then until dark there was a constant stream of whirlybirds evacuating the stranded and stunned persons."[79] The phrase "constant stream" was hardly an exaggeration. Air force helicopters landed at Refuge Point to evacuate those with less serious injuries, and both military and private aircraft transported those who had lost cars and trailers in the flood to the mouth of the canyon (for transport to Ennis or Virginia City) or to a ranch near Hebgen Lake (for transport to Bozeman).

Not only that, but early in the afternoon, continued Gerald, "Dr. Richard Nollmeyer of Bozeman and two nurses made their way to us on foot." The nurses were Rita Gilbert and Barbara Nute, also from Bozeman. Accompanied by Gar Lutets, Johnny Kinna and Danny Sprague of City Taxi, the doctor and nurses had walked four or five miles from Hebgen Lake Road to the dam. They had carried with them two pillowcases of medical supplies. "They said when they heard about the quake, they volunteered to try to get to us," wrote Gerald. "They were a great help. They patched everyone up, and made them ready for evacuation."[80]

All of the seriously injured victims waiting at the dam were evacuated by air force helicopters, four at a time, although the exact order is not known. All fifteen patients reached the hospital by early afternoon.

Warren and Esther Steele and Joseph and Ruby Armstrong were flown out together, as were Tony, Germaine and Bonnie Schreiber and Verona

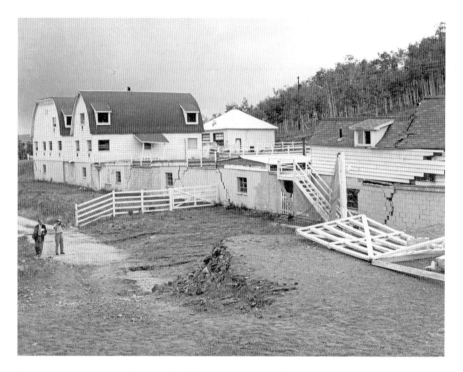

Soft-water entrepreneur Emmett J. Culligan's fortress against atomic attack was assaulted by other forces of nature. *U.S. Geological Survey.*

Holmes. For a period of time, all eight were together at the improvised hangar emergency room. Dr. Quinn said that of those eight, Ruby was the most seriously injured, with a compound fracture of her leg. Warren and Verona were both interviewed by reporters while waiting for the flight to Bozeman.

"My wife and I were sleeping in a tent," Warren said, his face bruised and bloody. "Suddenly, I was awakened and realized the ground was shaking. I rushed out of the tent and found rocks and dust flying off the mountain." He went back in the tent and got Esther. They saw a wall of water twelve feet high barreling down on them. It hit them hard. "We stumbled around over the rock. The water had ripped the pajamas off us, and we had no clothes. It was the worst experience I've ever encountered."[81]

The Maults and Olive Scott were flown out together, somehow fitting because, as noted previously, the three of them, along with Olive's husband, Clarence, and Mary Bair, had become friends before the earthquake and enjoyed a pleasant dinner on Monday night.

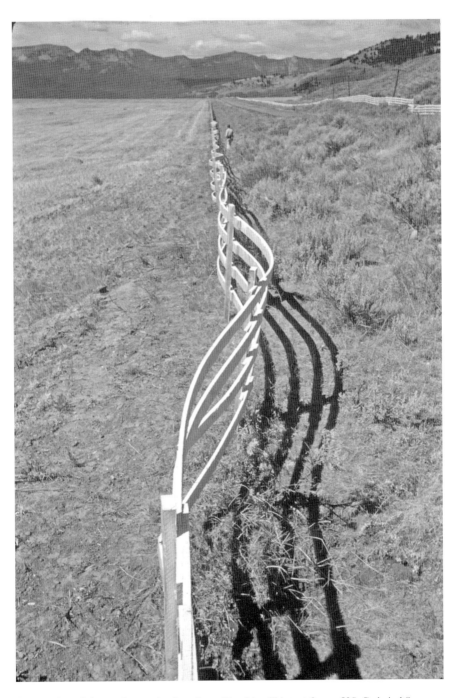

The waving of the earth was clearly reflected by this still intact fence. *U.S. Geological Survey.*

Mary, of course, had spent the night on the hillside with the twenty other people in the Ost/Frederick group. They had managed to get away with enough supplies to stay reasonably comfortable during the night and eat breakfast Tuesday morning. Then, like everyone else in the canyon, they waited.

"At 12 noon on Tuesday, the welcome sound of a small helicopter buoyed us all," wrote Elmer Ost.

Fred Gerlach had arrived. Sometime after 10:00 a.m., he had reached Sportsman's Lodge, a popular resort in Ennis, where Otis Crooker, owner of a private airstrip, had helped him fill up with gas. Then Fred had contacted Sheriff Brook, reviewed the situation in the canyon and proposed a plan. He studied the maps he had brought. He had to take precautions because he would be flying in thin air—Ennis was five thousand feet above sea level, and he had to ascend to the mountains from there. So he reduced his normal load of three or four adults to one of these options: two adults, one adult and two children or three children. He also had to watch out for other helicopters and the planes constantly buzzing around the canyon.

Next Fred flew to the temporary heliport near Kirby's Ranch to get familiar with the area where he would deliver his passengers. Hearing from previous reports about the group stranded on a ridge just northeast of the slide, he checked the map one more time and took off.

"The pilot made a daring landing in a strong wind on our out-jutting meadow slope (not as wide as the copter's landing skids were long)," wrote Elmer. "He reassured us we would get out. The two eye-injured persons (my wife, Ruth, and the Fredericks' nephew, George Whittemore) went first."

Fred flew Ruth and George to the landing area near Kirby's Ranch. They were driven by a highway patrol officer to the Ennis hospital, where Ruth remained. George's injury was so serious, however, that he was flown by helicopter to St. James Hospital in Butte for surgery. The pilot for that transfer was quite likely Fred's fellow helicopter pilot with the Johnson Flying Service, Rod Snyder. The attending physician at St. James reported on Tuesday night that George's condition was good and that his eyesight would be saved.

The next group flown out, said Elmer, was "a mother and two children"—Ann Smith and her daughters, Joann and Carol.[82] From that point on, Fred continued the same pattern—taking one adult and two children in each trip. In addition to those already mentioned, the passenger lists likely looked like this: Geraldine, Joan and Shirley Ost; Laura, Melva and Paul Frederick; Elsie Moore and her niece, Donna Ballart, and a nephew

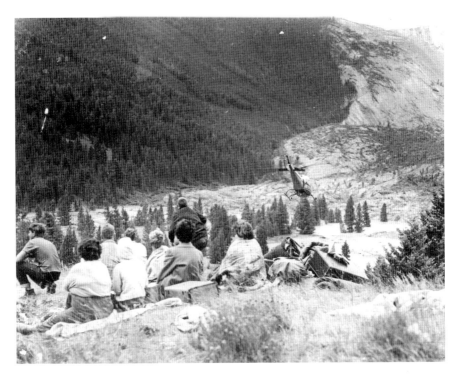

Watching pilot Fred Gerlach depart with three passengers, members of the Ost/Frederick/Smith/Bair group await their own evacuation. *Gallatin History Museum, Bozeman, Montana.*

whose name was not recorded; Mary Bair and Carol and Danny DeHart (also a niece and nephew of Elsie Moore). Thus, after a total of six trips—during which seventeen people were transported—three adult men (Elmer, Mel Frederick and Lewis Smith) and one teenage boy (Larry Ost) remained on the ridge. All four had obtained shoes or boots and could walk to a safer landing spot closer to the dam, so Fred picked them up there.[83]

The twenty-one people on the ridge—seen and counted by a number of different airplane pilots—were thus safely rescued. All were evaluated at the Ennis hospital and some admitted. The others were taken to the Ennis high school, where, once again, the Salvation Army and Red Cross provided warm meals, comfortable beds and good fellowship.

In a letter written a few days later, Elmer expressed thanks to the "Army, Navy, Mountain Patrol, Civil Defense, news service men, and helpful ranchers" who assisted his family and the other families in one way or another. He closed the letter with this tribute:

The Red Cross and people from the area provided money, food, clothes and homes for us all. Our gratitude knows no bounds ever as their generosity and graciousness are unlimited. We will never forget these last days. Our prayers of gratitude to God are mingled with prayers for the unknown number of dead and their anguished loved ones who cannot be sure—perhaps for several weeks—that the slide or the lake are the final resting place of the happy vacationers they miss.[84]

As the injured and the stranded were flown out of the disaster area throughout the afternoon, the majority of the two-hundred-odd campers waited for the chance to drive their vehicles out of the trap of a canyon. They knew bulldozers were clearing a temporary road through the thick forest and wondered how long it would take. When word came that the road wouldn't be ready until Wednesday, Florence and Doug Mander began to make preparations to spend another night in the canyon. "People then started to set up a camp because the clouds were hanging low and it looked as though a heavy storm might be starting," wrote Florence. Because they were now taking care of Pat and Don Armstrong (whose parents were

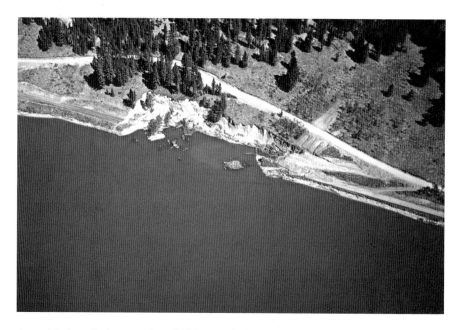

An aerial view of a large section of highway cast into Hebgen Lake by the quake and the temporary road bulldozed on higher ground. *U.S. Geological Survey.*

120

Culverts and bridges were particularly vulnerable to the 7.5 temblor. *U.S. Geological Survey.*

both in the Bozeman hospital), they had hoped to return to their home in Idaho Falls as soon as possible and get Pat and Don comfortably settled in guestrooms. There was nothing to be done, however, and the Manders and Armstrong children and Batemans fixed a meal of trout (caught before the earthquake), beans and sweet rolls.

Not long after that, however, a Montana Highway Patrol car pulled into Refuge Point, and the officer announced that the temporary road had been completed. "I have no words to express how I, myself felt," wrote Florence. "We were instructed to form a line, leaving the cars pulling trailers until last. This we did and started the precious journey out."[85]

9
"WHERE WE CAN'T EVEN HEAR THE BIRDS SING"

Evening newspapers for Tuesday, August 18, revealed that the earthquake was much more than a curiosity. In Canandaigua, New York, for example, a front-page story carried this headline: "Northwest Rocked by Severe Earthquakes; Dam Collapse Feared."

It was supplemented by two bulletins, also on the front page: "100 Motorists Trapped Between Rockslide, Dam; At Least Six Dead in Quake."[86]

Radio listeners in Montana and surrounding states got similar news much earlier because enterprising reporters had tape-recorded their descriptions of the slide while in flight over the canyon, and one radio station after another was broadcasting those recordings. The quake was huge news in Salt Lake City, Utah, and Idaho Falls, Idaho, two key gateway cities to Yellowstone Park. West Yellowstone, the Madison River Canyon and Island Park (a resort area just across the border in Idaho) were all popular vacation spots for residents of both Salt Lake City and Idaho Falls. So it was no surprise that concerned individuals in those two cities were among the first who tried to get word of relatives known—or presumed—to be camping in the canyon.

Early Tuesday morning in Idaho Falls, John Conley, forty-eight, was getting ready to catch a bus to his job at the Atomic Energy Commission "Site" (fifty miles west of Idaho Falls) when he heard a report on the radio that Rock Creek Campground had been buried by the landslide. The news threw him into a panic because his sons, Bill, sixteen, and Steve, eleven, were camping in the Madison River Canyon with his sister and brother-in-law, Polly and Hal Weston. They had left Saturday morning, August 15, excited

The man-built dam cracked but held while the nature-made mountain disintegrated into a torrent of destruction. *U.S. Geological Survey.*

and well prepared for a grand fishing trip. An aluminum boat was strapped to the top of the Chrysler station wagon, and the car was pulling a turquoise-and-white house trailer that would fit four people quite comfortably. On Monday, John and his wife had received a postcard from the boys saying they were camped at Rock Creek Campground and were having a ball.

Dropping plans to go to work, John called a friend to accompany him on the 120-mile ride to the canyon. Before they could leave, they heard on the radio that the roads in the area were severely damaged and that the Montana Highway Patrol had set up road blocks. John then called the Bonneville County Sheriff's Office and talked to a deputy, who volunteered to drive him as close to the slide as they could get. They left immediately.

The deputy took John as far as the roads allowed. An account written by a family member then picks up the story: "What then followed was John's desperate attempt to get to Rock Creek to his boys. Over the next several hours he hitched rides between road closures on a farm tractor, a motorcycle, and various cars. Finally reaching the shore of Hebgen Lake, he flagged down a boat owner." When he told the owner about his mission to find his sons, the man said that everyone still alive had been evacuated to West Yellowstone and if the boys weren't there, there was no hope. "He

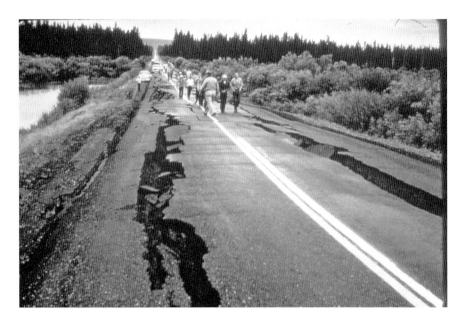

Visitors examine damaged highway north of West Yellowstone. *U.S. Forest Service.*

then retraced his steps to West Yellowstone to find that his boys were not at the airport. By that time, he was physically and mentally exhausted and lay down to rest."

Since John was the only person at the hangar who had launched an independent search for loved ones, he quickly drew the attention of a *Life* magazine writer, who took a photo of John sleeping on a bay of hay with a caption that read, "Anguished father lies under sedation after becoming nearly hysterical over news sons Bill, Stephen were missing"—an exaggeration because John was quite worried but not hysterical and had not been sedated.

A *Salt Lake Tribune* reporter also on the scene offered a different viewpoint: "The doctor [at the West Yellowstone Airport] told John Conley there was hope that his sons lived until they were found dead. A minister joined in. But John Conley had to know."

Tuesday evening, still with no definite information about his sons and mustering all the hope he could, John hitched a ride back to Idaho Falls.[87]

That same day, two other fathers had reason to be worried about their children.

Like John Conley, Rex G. Whitmore of Sandy (a suburb of Salt Lake City) was especially alarmed at hearing that Rock Creek Campground had been hit by the slide. His son-in-law, Mark, thirty, and daughter, Marilyn

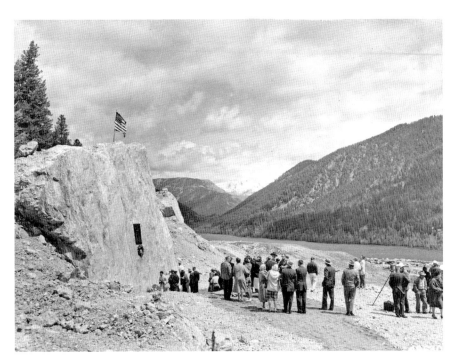

Visitors gather near the plaque at the close of the dedication services on August 17, 1960. *National Archives, photo by W.W. Gordon.*

Visitors reading the Highway Destruction sign, 1960. *National Archives, photo by Don Fritts.*

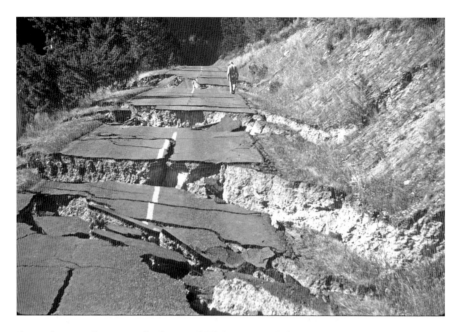

A man inspects damage to the fractured Highway 287. *U.S. Geological Survey.*

Whitmore Stowe, twenty-four, had left Monday morning on a fishing trip, with Mark mentioning that he wanted to fish the Madison River near Rock Creek Campground because his younger brothers, Robert and Richard, had had good luck fishing that spot a week and a half earlier. Rex, forty-seven, and his wife, Ferrol Smith Whitmore, forty-six, were taking care of Mark and Marilyn's only child, a three-year-old boy named Terry. Rex called Mark's brother Robert, a Salt Lake County deputy sheriff, to confirm the Rock Creek location and to see what Robert could discover. Robert said he would check all his sources of information and get back to Rex. They made tentative plans to drive north to West Yellowstone the next morning if they didn't hear from Mark and Marilyn.[88]

The minutes ticked by one by one as Rex and Ferrol waited.

In Idaho Falls, hometown of both the Conley and Mander families, Joseph J. Williams suspected that his son, Robert, thirty-two, and daughter-in-law, Coy McBride Williams, thirty-one, might be in the Madison River Canyon but hoped they weren't. They and their children—Steve, eleven; Mike, seven; and Christy, three—had left on a two-week vacation on Saturday, August 15, going first to Henrys Lake in Idaho's Island Park. Robert had not announced any plans beyond that—just that they would be

gone for two weeks and wanted to find a remote spot "where we can't even hear the birds sing." They didn't have a radio with them and wanted to leave the civilized world behind. Peace and quiet in the wilderness—that was the idea—whether that wilderness lay in Idaho, Wyoming or Montana. They wouldn't be worrying about Eisenhower and Khrushchev or thinking about *What's My Line* or *The Millionaire*. They had packed games and books, and Steve had brought along his mitt and baseball.[89]

Joseph and his wife waited and hoped Robert would call.

Meanwhile, one person definitely known to be missing in the disaster area was Mrs. Grace Miller, a sixty-five-year-old widow who single-handedly managed the Hillgard Fishing Lodge cabins and boat rentals on the north shore of Hebgen Lake, just above the dam. She lived alone in a cabin at the lodge. Searchers had found her cabin floating in the lake on Tuesday afternoon but had found no trace of Grace. Skin divers had been called in to search for her body.[90]

ON TUESDAY NIGHT, about the same time the Mander family and other stranded motorists were finally making their way out of the canyon (with the vehicles pulling trailers being pulled themselves by bulldozers), the Deaconess Hospital in Bozeman made an announcement: Mrs. Margaret Holmes had died of injuries sustained in the earthquake.

"The ordeal is one that will be hard to forget," said her son-in-law, Tony Schreiber.

Margaret Duffy was born in Montana in 1888 and married John James Holmes around 1911. They had one son and four daughters. John died in 1954 at the age of sixty-eight. Margaret died on August 18, 1959, at age seventy-one and was buried in the Harlowton, Montana Catholic Cemetery.

Many years later, Germaine and Bonnie made a trip back to the canyon and saw a film about the quake at the Earthquake Lake Visitor Center. "And then I seen that picture of my grandma being loaded onto the helicopter and that just startled me, and I started cryin'—I was having trouble catching my breath—it brought back a lot of memories. 'Cause I really loved my grandma." She added, "My grandma, she was quite a fisherman."[91]

EARLY WEDNESDAY MORNING, well before dawn, Rex Whitmore and Robert and Richard Stowe were on their way from Salt Lake City to Ennis, Montana. Road closures had forced them to go by way of Dillon, turning a 330-mile trip into one of more than 400 miles. It would be a long, somber journey and would take at least eight hours. They had

already learned that Mark and Marilyn's demolished car had been found on the downstream side of the slide, not far from the Bennett car. They had already learned that Irene Bennett had mentioned a young couple from Utah camping next to her family and that the unidentified body of a male adult had been found in the same vicinity as Pud Bennett and two of his three children. They were on their way to a mortuary in Ennis to see if they could identify the body.

As far as they knew, the body of a young woman had not been found; nor had anyone matching Marilyn's description been admitted to a hospital.

Ferrol was back in Sandy, now assisted by relatives, enduring a long, solemn day of their own, caring for and playing with a small boy who had possibly been orphaned. But even the word *possibly* offered a glimmer of hope.

Rex and the Stowe brothers had probably reached Montana by the time the phone rang at the Conley house, the phone call they had both hoped for and dreaded the entire night. But all dread vanished the second they heard Bill's and Steve's voices on the other end. The boys and Aunt Polly and Uncle Hal and even the dog were all OK. They had spent the night at a dormitory at Montana State University in Bozeman, but the road through West Yellowstone was open. They would be back in Idaho Falls that afternoon. What wonderful news.

"We left Refuge Point by helicopter at 5:30 PM the 18th," wrote Tootie Greene. "It felt good to get off the shaking earth for a while. We were left at a ranch on Hebgen Lake and near dark caught a ride in the vehicles leaving by a temporary road out of the canyon. Two young men from Washington State [Gil Gunderson and his nephew Jimmy Willie] took us home that night. They had befriended Steve all day, and their station wagon had served as our refuge and a resting place for the two injured ladies [Margaret and Verona Holmes]." Before leaving, Tootie gave all the medicine remaining from Dr. Bayles's visit to Frances Donegan, who was still waiting with her family to exit the canyon by car.[92]

When the temporary road did open, some kind campers, whose names are not known, gave Carole, Anne and Anita Painter a ride to Bozeman. Late Tuesday night, they reached the Red Cross center at Montana State University, where they learned their parents were in the Bozeman hospital. "We wanted to go see them," wrote Anita, "but it wasn't possible to arrange." Luckily, however, the girls' older brother, Ken, serving in the military in California, was flown to Bozeman to be with Ray and Myrtle.

Gil Gunderson (left) and his nephew Jimmy Willey transported victims in this station wagon and also gave the Greene family a ride to Billings. *Photo courtesy of Tootie Greene.*

"The Red Cross volunteers were so kind and understanding to us," added Anita, "we just felt safe and secure at last and so thankful to be there."[93]

Four events Wednesday afternoon set the tone for the pattern of events that would follow over the next two weeks: one family would get joyous news and another family troubling or tragic news, with hundreds of families eventually caught up in the diametrically opposed flow of circumstance.

Good news at the dam: Grace Miller was alive. When the quake had hit, she knew she had to get out of the house immediately. She picked up a blanket and kicked open a door. Below her was a five-foot-deep crevice. With her malamute dog, Sandy, at her side, she leapt across the crevice, just as the house fell into the lake behind her. "Rabbits wee skedaddling in every direction," she said, "but Sandy didn't even notice them." Barefoot, she hiked south through the sagebrush, staying near the lake but on high ground, until she found refuge at Kirkwood Ranch. The buildings there were damaged but not the campers. She was there, recovering, on Tuesday, when skin divers searched for her body in the lake. On Wednesday, a boater

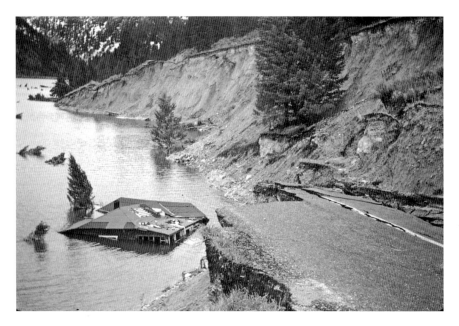

The slump of former Highway 287 into Hebgen Lake, with Grace Miller's Hilgard Lodge home drifting in the lake. *U.S. Forest Service.*

gave her a lift to the dam. On the way, they saw her nine-room home adrift in the water. "My teeth are still on the counter," she quipped, "right next to the sink."[94]

Heartbreak in the Madison River Valley: Rex Whitmore and Robert and Richard Stowe arrived at the mortuary in Ennis and steeled themselves as the coroner pulled back a sheet covering a body. It was Mark, which dashed hopes of finding Marilyn alive. "Mark was a light sleeper," the Stowe brothers reported. "It is possible that Mark may have heard the rumble and jumped out of the tent to see what was happening when the slide hit him and knocked him free." After making arrangements at the mortuary, the three men got permission from authorities to search the slide area themselves. Rex searched until his hands were bleeding but found no trace of his daughter.[95]

Thrilling news in California: Kathryn Stryker received word that Martin had survived and was unhurt. Martin had been reunited with his brothers in Virginia City, at the home of Gil Evans. "The Evans family was very gracious and welcoming," he wrote. "Gil owned a local shop that sold semi-precious gems indigenous to the area, and Virginia City was a busy place." Edgar Stryker had been employed by United Airlines, "which arranged a

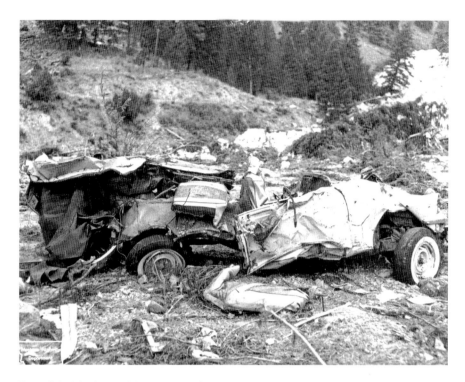

Demolished by the landslide, the car of Mark and Marilyn Stowe lies near the dry riverbed. *Gallatin History Museum, Bozeman, Montana.*

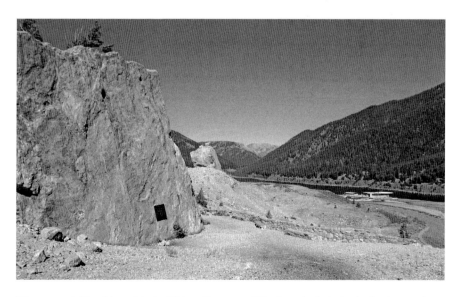

The memorial boulder, with the Visitor Center and Earthquake Lake in the background, 2015. *Photo by the author.*

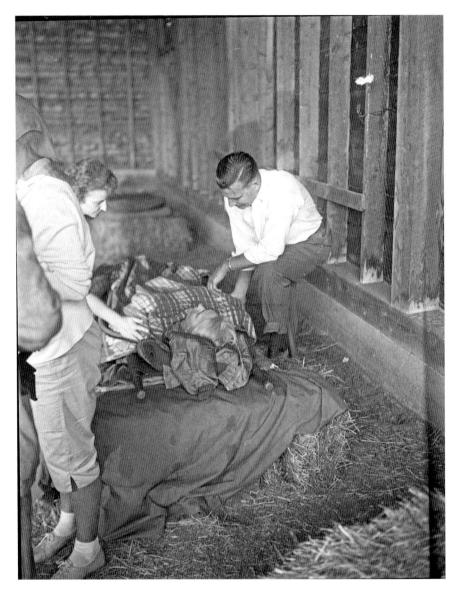

Medical personnel attending to an injured survivor. *Utah Historical Society, photo by the* Salt Lake Tribune.

flight from Butte to Seattle and then home to the San Francisco Bay area. Needless to say, it was great to be reunited with our Mother."[96]

Another sad report at the Ennis hospital: By Tuesday night, Irene Bennett had been told that Carole's and Tom's bodies had been recovered, but she

At Refuge Point, rescuers carry victims to an air force helicopter. *Photo courtesy of John Owen.*

held out hope that Susan would be found alive. At the same time, she was worried about Phil. "His leg was broken in several places and would require surgery," she wrote. "To our advantage Doctor Losee had recently returned from having studied advanced orthopedic surgery in Montreal, Canada. My mind wrought with worry of losing my son I prayed, 'Lord, spare this child.'" Wednesday afternoon brought the last of four sad reports. "At last Susan's little body was found," wrote Irene. "I now sobbed for her missing her first exciting days of school and not having the opportunity to grow up and be a lovely young lady."[97]

10

"HER FINAL RESTING PLACE"

On Wednesday evening, Polly and Hal Weston and Bill and Steve Conley were back in Idaho Falls. The twelve-foot aluminum boat was still at Cliff Lake and the comfortable thirteen-foot travel trailer now deep in the new lake, but none of four individuals had been hurt. They told the full story.

"We arrived at Rock Creek early Saturday afternoon to find only a single campsite open," Bill wrote decades later. "The campground was beautiful, sitting on the East bank of the Madison River. It was densely forested with towering trees, some three feet in diameter. The camp sites were spacious and deeply shaded and occupied with a mixture of tents and trailers, all with families of happy campers."

On Monday, the day of the earthquake, Hal and the boys drove to Cliff Lake for a great afternoon of fishing. "We arrived back at the trailer just before dark. Polly prepared a delicious fresh trout dinner. We were exhausted and almost immediately dead to the world, anxious for another great day of fishing in the morning. The night was clear, the moon was full and the only sound was the gentle ripple of the nearby river."

Then Bill "awoke to the most deafening roar anyone could possibly imagine. In that first few nanoseconds my mind tried to understand the noise." He and a friend had camped near a railroad track in Island Park only two weeks earlier, and "a train came barreling down on us in the middle of the night scaring the life out of both of us." He immediately thought the same thing was happening again but then remembered there were no tracks in the canyon.

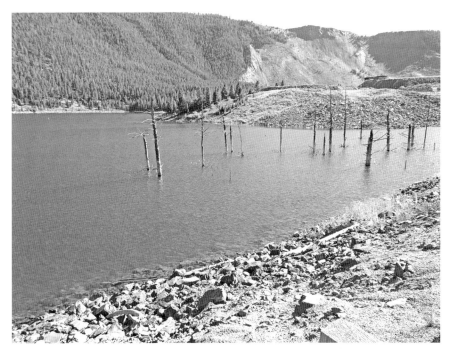

This edge of Earthquake Lake now covers the approximate area of Rock Creek Campground, where the Painters, Holmeses, Greenes and others were camped. *Photo by the author.*

"I raised up in the back of the car and looked out the window to see Polly and Hal standing in the doorway of the trailer, backlit by the lights inside, both looking skyward at the mountain on the other side of the river. I rolled down the window and asked what was happening. Polly said, 'It's an earthquake!'"

Bill and Steve heard the sound of a large tree splitting and falling. "It seemed to last an eternity. That tree was immediately across the road and came to rest right on top of the outhouse. In the doorway and with the full moon, Polly and Hal could see movement of the mountain momentarily before everything became obscured by dust in the air."

They were not far from the Holmeses and Painters and others but far enough that the slide didn't reach their camp. "All of us were dressed and outside in a heartbeat. No moon, dust so thick we could hardly breathe, black as the inside of a cow and deathly quiet. The trailer lights were the only things to be seen. We stood there for a short time trying to get our bearings and trying to digest what had just happened. Then we began to hear screams and calls for help."

Hal grabbed a flashlight, and Bill followed him toward the voices calling for help. "Polly and Steve remained with the trailer. I will admit to never

having been so scared in my life and Hal wasn't far from that either! We didn't get more than seventy-five feet when we encountered a forest of trees, all down on the ground like a giant game of pick up sticks."

They couldn't go any farther but could see the reflection of white aluminum buried in the mass of trees, likely from a buried trailer.

"The next few minutes are a blur. I remember feeling like I had a gun pointed at my head that could go off at any minute. We could see no way in the darkness and thick dust to try to find or help anyone. We retreated to the light of the trailer."

They had hardly reached the trailer when injured campers began making their way to the lights of their camp. "Nearly all were injured, some seriously with obvious broken bones and lacerations. Polly began to administer first aid as best she could with limited supplies."

Some of the first victims to reach the trailer were Tony and Germaine Schreiber. Polly took Bonnie, which allowed Tony and Germaine to search for Verona and Margaret. Years later, Bonnie, like many others, remembered Polly almost with reverence. "When they [apparently Dr. Bayles and Jane Winton] put the stitches [near her injured eye] in," Bonnie said, "they had to do it without deadening the area because they had no idea whether I was allergic. They thought I was going to lose my right eye. But my right eye's fine." She still remembered Polly holding her hand during that ordeal.[98]

ON FRIDAY, AUGUST 21, a few short paragraphs in the *Deseret News* told volumes about Utah victims of the quake:

> *The death toll Friday stood at nine identified and one unidentified woman. Latest addition to the death list was Mrs. Myrtle Painter, 42, of 4345 Porter Ave., Ogden.*
>
> *Mrs. Painter died in a Bozeman hospital Thursday at 11:30 AM [actually 1:00 p.m.]. She was evacuated from the slide area Tuesday by helicopter. Her husband, Ray, is still in the hospital. The couple's three daughters, Carole, 16, and twins Anne and Anita escaped injury.*
>
> *Mrs. Painter is the second Utahn known to have died in the quake disaster. The other identified dead Utahn is Mark Stowe, 31, of Sandy.*
>
> *Mrs. Marilyn Stowe, his wife, is believed dead, but her body has not been recovered. Her father, Rex K. Whitmore, 8060 7th East, reported from Virginia City that he was continuing to search even though the organized hunt for bodies has been called off.*[99]

Carole, Anne and Anita were already back in Ogden when they were told that their mother had died. The last time they saw her was when she was loaded onto the Hill Air Force Base helicopter. Anita writes movingly of their experience during and after the disaster in her book, *Shaken in the Night*.

Myrtle Lavina Oram was born on November 6, 1916, in Liberty, Utah. Her father died of diabetes when she was seven years old. In the mid-1930s, she was working in a café in the mining town of Eureka, Utah, and met Ray Painter there. They were married in 1937. During the war, Myrtle worked at the Ogden Arsenal, where she helped make ammunition. At the time of her death, she was managing the bakery at an American Food Store. Her obituary noted that during her long wait for medical help, "never once did anyone hear a word of complaint from her lips."[100]

Myrtle was the last person to pass away from earthquake injuries. Irene and Phil Bennett, the Scotts, the Armstrongs, the Steeles, the Schreibers, Verona Holmes, the Maults and all the others would survive.

FRIDAY, SEVERAL VEHICLES FULL of men left Salt Lake City and drove north. Twenty members of the Salt Lake County Sheriff's Jeep Patrol were present, as well as thirty-three friends and relatives, many of whom were members of the Mormon congregation attended by Mark and Marilyn. They started their search early on Saturday morning, August 22.

"A force of fifty-three men with picks, shovels, and axes formed a net across the 300-yard canyon at the foot of the giant slide," wrote a newspaper reporter. "Then slowly the net creeped along working its way down the river bed and along its adjoining canyon floor." About one hundred yards from the foot of the slide, the searchers saw two smashed hunks of metal hardly recognizable as cars—one that belonged to the Stowes and one to the Bennetts. When articles belonging to Marilyn were found—a sleeping bag and a woman's purse—hope was strong that her body would be located, covered with a blanket and tenderly lifted into a station wagon to be transported to a morgue and given a proper burial. But it was not to be.

"A simple, moving prayer, offered in the shadows of a[n] 85-million ton landslide across Madison Canyon 15 miles northwest of here [West Yellowstone], Saturday marked the end of a sorrow-choked search for the body of a 24-year old Sandy, Utah, woman," continued the article.

"About 40 friends and relatives of Mrs. Marilyn Whitmore Stowe listened with bowed heads and tear-dimmed eyes as Bishop John C. Richards of the Sandy First Ward, Church of Jesus Christ of Latter-day Saints, conducted a simple religious service."

As the sun began to set, Rex Whitmore had called off the search, and the group gathered near where Mark's body had been found Tuesday. Bishop Richards kneeled and offered a prayer.

"If Marilyn's body is not found," he said, "we ask thee to accept this as her final resting place."

Then he prayed that Marilyn's loved ones would be blessed with comfort and peace.

Rex Whitmore had devoted himself to the search for three days, but now, his face grim with weariness, he told his friends and neighbors the search had ended. "I had a feeling that if we did not find her this afternoon, it was no use," he said.

The reporter described the scene: "He [Rex] tried to thank each of the searchers, but words failed him. Silently he moved around the circle of dusty, tired men, giving each a handshake.

"'There wasn't one of us who didn't shed a tear,' reported Salt Lake County deputy sheriff C.W. Brady, one of the jeep patrol members."

When the simple ceremony ended, the men climbed into their vehicles and drove away. As the reporter observed, "Nothing more could be done."

Marilyn would have turned twenty-five exactly one week later.

Thomas Mark Stowe was born on May 22, 1929. He attended Brigham Young University and served in the Army Medical Corps in Korea. He was a music teacher in the Jordan School District. He and Marilyn were married on November 24, 1954, in the Mormon temple in Salt Lake City.

Marilyn was born on August 29, 1934. She attended Brigham Young University for one year and was affiliated with the Cami Los social unit. Funeral services were scheduled for Tuesday, August 25 at 1:00 p.m. at the Mount Jordan High School auditorium in Sandy, Utah.

Mark and Marilyn's son, Terry, was told about his dad. "Nothing can happen to my dad," he said. "I need my dad so much." He had not yet been told about his mother.[101]

JOSEPH WILLIAMS HAD BEEN searching for his son and daughter-in-law and their children since Wednesday.

"We know that they were at Henrys Lake Saturday night and Sunday morning before the earthquake," Robert's mother told a reporter on August 22, the same day the search for Marilyn Stowe ended.

Joseph had next traced them to a museum in Virginia City. They signed the register Monday—apparently late in the afternoon because their names were toward the end of the list. They had not been heard from since then.

Mark and Marilyn Stowe with their son, Terry, during Christmas 1958. *Photo courtesy of Terry and Sydnee Stowe.*

Still, there were reasons to be hopeful. First, scores of people thought to be missing in the quake had been accounted for in the last couple days. That trend was expected to continue for the next few days. On Saturday,

Terry (eighth from left, standing) and Sydnee (seated beside him) Stowe and their family, 2015. *Photo courtesy of Terry and Sydnee Stowe.*

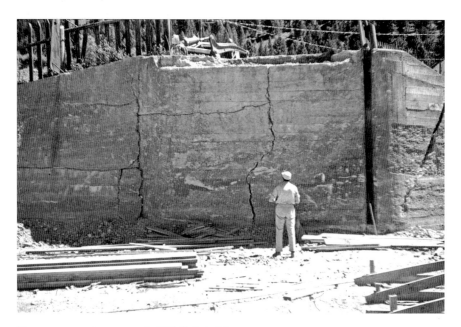

No cement structure was safe. *U.S. Geological Survey.*

for example, five days after the quake, several families arrived in Idaho from Yellowstone Park, amazed that they had been listed as missing.

Second, the family was not due back for another week. It was hoped that they were camping in a safe spot and were unaware of the extent of the damage caused by the earthquake.

It had been announced to authorities that the Williams family was traveling in a 1959 light blue Ford with white trim. The car was pulling a yellow and white trailer.[102]

On Wednesday, August 19, the Billings paper had run a notice that Mr. and Mrs. George Horning and Mr. and Mrs. Bernie Boynton, all of Billings, were reported to have been fishing in the Hebgen Lake or Ennis area, and latest reports were that none of them had been heard from since the quake.

Two days later, the Hornings were reported safe, but there was still no trace of the Boyntons.[103]

On Tuesday, August 25, more than a week after the quake, more names were added to the list of missing, with one newspaper announcing a missing persons case different from all the others: "Fear was expressed yesterday for a Havre man missing in the rugged Beartooth Mountains southwest of Red Lodge." The man in question, Ernest Bruffey, thirty-eight, was a former Northern Montana College instructor, a prominent citizen of Havre and a noted photographer. He had extensive experience hiking and backpacking in the mountains and was prepared for cold weather. He had told others of his intent to climb Granite Peak, the highest mountain in Montana (about sixty-five miles northwest of Hebgen Lake), with plans to leave on Sunday, August 16, and return Wednesday, August 19. He had a wife and four children. "Granite Peak is not in the immediate earthquake area," continued the article, "but strong shocks were recorded there from Monday night's earthquake."[104]

The other notice published that Tuesday was much more similar to the hundreds of alerts that had started going out within hours of the disaster. An American Falls, Idaho family—William Razdoroff, his wife and their three children—had left their home on the morning of Monday, August 17, for a two-week vacation. They planned to spend the first week in the Yellowstone Park area and the second in Glacier National Park.[105]

A review of the Red Cross missing persons lists published over a five-day period offers a glimpse of the roller coaster of emotions that anxious families must have experienced.

On Sunday, August 23, the Red Cross emergency headquarters in Bozeman announced that more than 2,300 inquiries had been received from concerned relatives. Some 1,500 to 1,800 of the people asked about could not be immediately traced, but a spokesman said many later turned up safe. However, the Red Cross added that many of the missing were known to have been close to the quake site.[106]

On Monday, August 24, a list of eighty-eight missing people was announced. They had been repeatedly inquired about, but nothing had been heard about or from them since the night of August 17. The following individuals were included in the list:

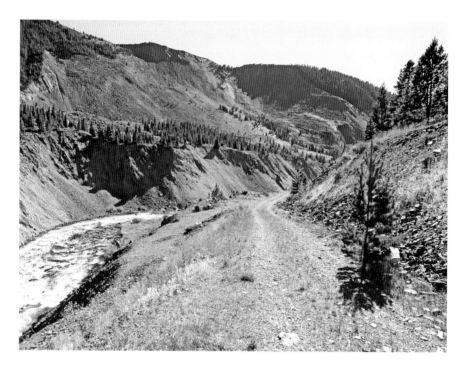

The spillway, on the left, flows over the approximate spot of the meadow where nineteen people were lost in the slide. *Photo by the author.*

Laird Allen, wife and two children, Clairton, Pennsylvania.
William Baxter, wife and two children, Merchantsville, New Jersey.
B.L. Boynton and wife, Billings, Montana.
Oliver Calhoun, wife and two children, Pendleton, Oregon.
Frank K. Dobbins, wife and two children, Van Nuys, California.
Merle Edgerton and wife, Coalinga, California.
The Reverend D. Enns, wife and two sons, Portland, Oregon.
Robert Finch, wife and two children, Highland, Indiana.
Harold Goodman, wife and two sons, New York City.
Louis Gulbranson, wife and one child, Niles, Michigan.
Milford Kellogg, wife and two sons, Damascus, Maryland.
Hugh L. Moore, wife and two children, Los Angeles.
Kenneth Mulford and wife, no hometown listed.
Navy lieutenant Harry W. Patch, wife and two children, Wakefield, Massachusetts.
Roger Provost, wife and three children, Soledad, California.
William Reynolds and wife, Lake Orin, Michigan.
Dr. John Rupper, wife and four children, Provo, Utah.
Mrs. Stella Rupper and Michael Rupper, Provo, Utah.

Herman Schulund, wife and son, Havre, Montana.
Kurt Stine (or Stein), Seattle.
Arthur Ullman and wife, Davenport, Iowa.
The Reverend Harry Vix and wife, Martin, North Dakota.
Lloyd Webster and wife, Santa Rosa, California.
Frank Welt, wife and three children, New York State, no town listed.
Robert J. Williams and three children, Idaho Falls, Idaho.
Harmon Woods and wife, Coalinga, California.[107]

The Razdoroffs and Ernest Bruffey were not included in this list because it was compiled the same day they were reported as missing.

On Thursday, August 27, Sheriff Skerritt, who had taken over handling of the disaster list from the Red Cross, said officials were convinced that the following people had been killed in the slide at Rock Creek Campground:

Mr. and Mrs. Boynton, Billings, Montana.
Mr. and Mrs. Sidney D. Ballard and son, Christopher, Nelson, British Columbia.
Mrs. Thomas M. Stowe, Sandy, Utah.

Thirty-seven others were listed as unaccounted for—people who had possibly been in southwestern Montana the night of August 17:

Dr. Merle Edgerton and wife, Edna, Coalinga, California.
Harold Gaines, wife Phyllis and three children, San Diego, California.
Donald Heady and wife, Irene, Syracuse, New York.
Arthur Holden and wife, Ruth, Sioux Falls, South Dakota.
Dr. Harold S. Murphy, wife and three children, listed only as from Pennsylvania.
James Peak, wife, son and friend, Saginaw, Michigan.
Roger Provost, wife and two sons, Soledad, California.
Norman Smeds and wife, Winifred, Medford, Oregon.
Robert J. Williams, wife and three children, Idaho Falls, Idaho.
Harmon Woods and wife, Edna, Coalinga, California.
Fred C. Wrobbel, wife Evelyn, and two sons, Rosiclare, Illinois.[108]

By this time, the Razdoroffs had been found safe in Glacier National Park.[109] Ernest Bruffey, however, was still missing, with his case being

frequently mentioned by the newspaper in Kalispell, Montana. Why he was not included in the list above is not known.

The fact that several of these people had never before been listed as missing reveals just how uncertain the situation was.

An article in the Billings paper explained details about what had to be an agonizing search for the Boyntons:

> *Relatives of Mr. and Mrs. Bernie Boynton held the belief Wednesday the Billings couple are buried under a slide that swept Madison River Canyon on August 17. A search party returned Wednesday after a fruitless hunt for clues in the quake-shaken area. The party, made up of Mike Denda, New York, Mrs. Boynton's brother, Marilyn Moes, Mrs. Boynton's daughter, Mort Boynton Jr., Mr. Boynton's son, Harry Wardell and Frank Pierce, close family friends, left Billings Monday and returned early Wednesday morning.*
>
> *The search started at Bozeman where the group interviewed several slide survivors in a Bozeman hospital. A Mr. Armstrong recalled seeing Mr. Boynton in the fatal slide area. Mr. and Mrs. Clarence Scott, when furnished with a description of the Boynton's car and trailer, were almost positive the Billings couple was parked in the Rock Creek campground in an area known as "The Point" about 4 p.m., either Sunday or Monday.*
>
> *Verification that the Boyntons were in the area was obtained from a service station, where records indicated they bought gasoline at 3 p.m. Sunday, and were headed for the park....The next move was an interview of still another survivor, Mrs. P. Bennett, in an Ennis hospital who could throw no light on the search....The search ended at the slide, where a construction foreman sent one man below the slide to check the license number of a blue car stranded below the area. The license number did not check with the Boynton's car.*[110]

Over the next few days, names continued to be added and deleted from the list. It was not until Tuesday, September 1, fifteen days after the quake, that a final list of individuals presumed to be lost in the slide was released:

Sidney, Margaret, and Christopher Thomas Ballard, of Nelson, British Columbia.
Bernie and Inez Boynton, of Billings, Montana.
Merle and Edna Edgerton, of Coalinga, California.
Roger, Elizabeth Findlay, Richard and David Provost, of Soledad, California.
Marilyn Whitmore Stowe, of Sandy, Utah.
Robert, Coy, Steve, Mike and Christy Lynn Williams, of Idaho Falls, Idaho.
Harmon and Edna Woods, of Coalinga, California.[111]

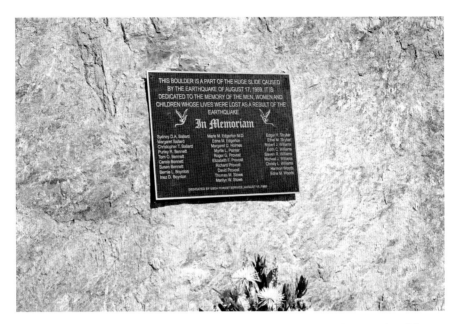

This memorial plaque was unveiled at the 1960 dedication service. The plaque reads as follows:

THIS BOULDER IS A PART OF THE HUGE SLIDE CAUSED
BY THE EARTHQUAKE OF AUGUST 17, 1959. IT IS
DEDICATED TO THE MEMORY OF THE MEN, WOMEN AND
CHILDREN WHOSE LIVES WERE LOST AS A RESULT OF THE
EARTHQUAKE

In Memoriam

Sidney D.A. Ballard	Merle M. Edgerton M.D.	Edgar H. Stryker
Margaret B. Ballard	Edna M. Edgerton	Ethel M. Stryker
Christopher T. Ballard	Margaret D. Holmes	Robert J. Williams
Purley R. Bennett	Myrtle L. Painter	Edith C. Williams
Tom O. Bennett	Roger G. Provost	Steven R. Williams
Carole Bennett	Elizabeth F. Provost	Micheal J. Williams
Susan Bennett	Richard Provost	Christy L. Williams
Bernie L. Boynton	David Provost	Harmon Woods
Inez D. Boynton	Thomas M. Stowe	Edna M. Woods
	Marilyn W. Stowe	

DEDICATED BY USDA FOREST SERVICE, AUGUST 17, 1960
Courtesy of the U.S. Forest Service.

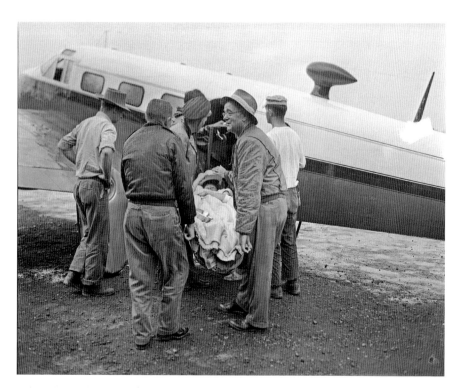

Above: What later became known as the memorial boulder rests atop the slide in this photo, taken within days of the quake. *U.S. Forest Service.*

Opposite, top: A victim being loaded onto a Johnson Flying Service plane for transport to the Bozeman hospital. *Utah Historical Society, photo by the* Salt Lake Tribune.

Opposite, bottom: With rising water in Earthquake Lake threatening to overtop the slide and flood downstream, crews worked long hours completing the spillway. *U.S. Forest Service.*

This brought the total number of earthquake-related deaths to twenty-eight.

Although several searches for Ernest Bruffey were conducted, including one in which smokejumpers participated, his body was never found. In 2000, forty-one years after he went missing, a few human bones and a weathered boot sole were found by hikers on Granite Peak. The bones are presumed to be the remains of Ernest Bruffey.[112] Why he was never included on any official list of earthquake victims is not known. Good evidence indicates, however, that he was indeed the twenty-ninth victim of the Yellowstone earthquake of 1959. He deserves to be recognized as such.

EPILOGUE

I learned how wonderful people are." That's what Anita Painter Thon said about her memories of the earthquake when she spoke in West Yellowstone in 2014.[113] A similar spirit has been manifested by many others involved in the quake.

There was great outpouring of love at the memorial service for the Williams family on September 4, 1959, in Idaho Falls. Music was a key part of the service. The congregation sang "Whispering Hope," Don Watts sang "Nearer My God to Thee," Louise and Madge Egbert sang "Sunset," Mack Reynolds sang "Beyond the Sunset" and Virlow Petersen sang "I'll Walk with God." American Legion Post 56 presented the flag and taps. A dedicatory prayer was later given at the site of the slide.[114]

Martin Stryker lost his dad, Edgar, and his stepmom, Ethel, in the quake, but in 2015, he wrote, "One of the nice things that happened is that we [he, his brothers and his mother, Kathryn] became closer to Ethel's family and we are still close to them."[115]

Grover and Lillian Mault were forever grateful to their rescuers. They are known to have corresponded with Tootie and Ray Greene and with Frances and Fred Donegan and no doubt did so with others. Tootie remembered that Lillian sent the Greenes a Christmas card every year until she died in 1972 at age eighty-one; Grover died in 1980 at age ninety-two.[116]

One year after the earthquake, Joseph and Ruby Armstrong visited the Donegan family in Vandalia, Ohio. Joseph made a special trip to the editorial office of the local newspaper to sing the praises of Frances Donegan.

Martin Stryker and his wife, Nancy, 2010. *Photo courtesy of Martin Stryker.*

"Vandalia should be proud to know it has a woman living here like Mrs. Donegan. She is a remarkable person. If it hadn't been for Mrs. Donegan, I wouldn't be here to tell about [the earthquake] now."[117]

Fred Donegan died in 1972 at age sixty-four, Frances in 1999 at age ninety-one.[118]

Had he visited Idaho Falls, Idaho, Joseph would no doubt have heaped similar praise on Florence and Doug Mander, who helped them when they were injured and took care of their children while they were in the hospital.

Joseph Armstrong died in 1995 at age eighty-seven, Ruby in 2007 at age ninety-three.[119]

Florence Mander died in 1996, Doug in 2006 at age ninety. As Doug's obituary noted, "The Manders ran Doug's Dairyland Kitchen in Idaho Falls from 1963–1981, serving great food in congenial company."[120] Doug's Dairyland was the author's favorite spot for a grinder sandwich and a chocolate milkshake in the late '60s.

Warren Steele died in 2000 at age seventy-seven, Esther in 1999, also at age seventy-seven.

Tony Schreiber died in 1995 at age eighty-one, Germaine in 2008 at age eighty-nine. Verona Holmes died in 2003 at age eighty-nine.[121]

Hugh Potter died in 1964 at age sixty-two, Dr. Raymond Bayles in 1985 at age eighty-three, Dutch Buhl in 1985 at age sixty-seven and Glen Stevens in 1999 at age eighty-one.[122]

Smokejumpers Bob Nicol and Al Hammond were present at the Earthquake Lake Visitor Center for the fortieth anniversary of the earthquake in August 1999. They met survivors and saw nine jumpers parachute into Refuge Point. Of the original crew, Dick Tracy had died in 2006 at age seventy-three, Randy Hurst in 2003 at age seventy-three and Joe Roemer in 1997 at age sixty-four.[123]

Forest Service ranger Joanne Girvin has been at the Earthquake Lake Visitor Center since 1990. She has met several earthquake survivors and has told the story of the disaster to thousands of tourists. She has helped countless reporters and researchers over the years. One survivor who has assisted her is John Owen, who was fifteen and camping at Halford's Camp when the quake struck. John purchased property just beyond the mouth of the canyon and has given freely of his time—and his photographs—to share his experience with others. The same is true of Bill Conley, who, like John and Martin Stryker, was fifteen at the time of the quake. John and Bill both spoke at the fiftieth anniversary program in August 2009.[124]

Anita Painter Thon and her husband, Steve, also attended the 2009 program. She met three of the original smokejumpers and hugged and thanked them. She also met Terry Stowe, who had been raised by his mother's parents, Rex and Ferrol Whitmore. Rex and Ferrol died in 1999 and 2003 at the ages of eighty-seven and ninety, respectively.[125] Terry said he had had a good life. Most meaningful for Anita, she was able to meet, thank and hug Tootie Greene, the first person other than Carole to help Myrtle. Anita and Tootie had a very pleasant conversation.

Ray Painter died on March 13, 1996, at the age of eighty-three. He had married Lois Winger in 1964. Life was not easy for him or the girls after Myrtle died. All three of his daughters were still alive in 2015; only Anita had gone back to the Madison River Canyon.[126]

Martin Stryker was also present at the fiftieth anniversary and was one of the speakers. Martin had graduated from the University of Oregon in marketing and finance. He is now retired from Deloitte, the global accounting and consulting firm. John H. Stryker worked in consulting and mortgage finance. He was a history graduate of the University of California, obtaining his PhD from the University of Indiana. He died at age forty-nine. Morgan E. Stryker was a graduate of the University of California–Santa Cruz and UC–Davis. He works as a physician's assistant.[127]

From left to right: Carole, Ken, Anne, Ray and Anita Painter, early 1960s. *Photo courtesy of Anita Painter Thon.*

Irene Bennett Dunn lived an incredible and inspiring life. In 1998, she published *Out of the Night: A Story of Tragedy and Hope from a Survivor of the 1959 Montana-Yellowstone Earthquake.* The book gives a heartrending account of how she and Phil, who stayed in the hospital longer than any other victim, returned home to an empty house in October 1959 and spent their first Christmas alone two months later. Phil married and had children. Irene went back to college, graduated and taught grade school for fifteen years.

In 1962, she married Jack Dunn, her high school sweetheart. They were married until Irene's death in 2007 at age eighty-seven. "We know God works in mysterious ways and time has helped us realize His plan," Irene wrote. "It is said He often breaks our hearts so He can beautify our lives."[128]

Tootie Greene's life was never the same after the earthquake. She received numerous awards and honors and was featured in a 1960 *Reader's Digest* article entitled "I Only Did What I Could." She and Ray continued to live in Billings, where Tootie has had frequent requests for information from all sorts of researchers and writers. She handles all of it with good humor and optimism. Ray died four days after turning seventy-five. Quoting from his obituary:

> *"I lived a good life and am at peace." So ended the brief struggle Ramon Lee Greene made as he died at home with the care of family and hospice on Sunday, Aug. 31, 2003....He married Mildred "Tootie" Bettle on Dec. 7, 1948, in Deer Lodge, the start of almost 55 years of happy family life with a son, Steve, his wife Sherry and grandson Brian who live in Missoula....Please, no flowers for the family. Give your love to another as that is the greatest gift and best memorial for Ray. Cremation has taken place and a memorial service will be at 10 AM Monday at*

Pastor Tom Letts speaks at the fortieth anniversary memorial service; Irene Bennett Dunn and her husband, Jack, were among those present. *Photo courtesy of Bob Nicol.*

Above: Tootie, Ray and Steve Greene, 1990s. *Photo courtesy of Tootie Greene.*

Right: Tootie Greene at her Montana home. *Photo courtesy of Tootie Greene.*

Michelotti-Sawyers Mortuary with burial of ashes at Sunset Memorial Gardens and scattered with his fishing buddies Edna and Page Spencer along the Gallatin River.

Steve, nine at the time of the quake, never seemed to pay much attention to all the hubbub surrounding his mother. "All he could remember," Tootie said, "was the helicopters and how big a deal that was." Later in his life, however, without telling Tootie, he went back to the Madison River Canyon, saw the slide and the plaque and toured the Visitor Center and read the literature. Years later, he told Tootie about the visit. "Mom," he said, "you did good."[129]

LIST OF INDIVIDUALS EVACUATED FROM THE EARTHQUAKE AREA

The following list released by the Associated Press is reprinted below exactly as it was originally published in the *Billings Gazette* on August 21, 1959. Corrections by the author are shown in brackets.

BOZEMAN (AP)—Here is a partial list of evacuees who left the southwest Montana earthquake zone by way of Dug Creek, Wyo., and Bozeman, Mont., obtained through the Red Cross, Montana Highway Patrol and the U.S. Forest Service:

(Addresses unavailable where not listed)
Caraway, West [Les] and wife, from Hebgen Dam.
McFarland, Gerald; wife and daughter, Salem, Ore.
Yaklish, A.J., Woodenville, Wash.
Thompson, Mike, Udall, Kan.
Maxwell, V., Jr.
Thompson, June; man, woman, daughter, and aunt.
Martin, A.F.
Davis, Mrs. Ben.
Drake, Miss Goldie.
Davis, B.W., Tarlton, Miss.
Sanders, Leland L., wife, daughter, Ina Jean, Roy, Utah.
Thomas, Mrs. David, three children, Nye, Mont.
Rogers, Mrs. Charles, three children, Roundup, Mont.
Wood, Mrs. Ethel, son Harry, Salt Lake City, Utah.

Curtis, L.H. and wife, Pasadena, Calif.

Balack, Clarence M., wife, one small girl, mother-in-law, Middleton, Mrs. Erma, Tucson, Ariz.

Blaydon, Richard, wife, North Hollywood, Calif.

Tovias, Louis; wife Kay, daughter Karen, Akron, Ohio.

Lorenze, Mrs. Fred, Akron, Ohio.

Genderson, Gilbert, Bellevue, Wash.

Willie, James B., Tacoma, Wash.

Badoviwax, John; wife, two children, Seattle, Wash.

Burley, Robert; wife.

Goodnough, Jack; wife, three children, Albion, Wash.

Wils, Wilfor; wife, four children, Brigham City, Utah.

Davis, John B.; Carolyn, Pocatello, Idaho.

Wizel, Fred; wife, four children, Aberdeen, Wash.

Hudson, Charotta, Twin Falls, Idaho.

Rost, Eleanor.

Greenaway.

Kraeter, Eugene G.; wife, Jean, Concord, Mass.

Bernard, Hayward; wife, three sons, Escondido, Calif.

Melchon.

Cooper, William E.

Webb, Glenn.

Engle, F.N., wife, Garden Grove, Calif.

Robert W. Dean, wife, two children, Nancy, Cynthia, Salt Lake City, Utah.

Daea, John Sr., Great Falls, Mont.

Stranger, J.F. and Leo.

Triempower, E.

Buser, Jack; wife, Harrisburg, Penn.

Bateman, Rex; wife, Utah.

Hobeson, C.W.; wife, two boys, Estan and Gary.

Three Painter children, Ogden, Utah.

Own, O.B., Culver City, Calif.

Searcy, J. Spencer; wife, Don, Ralph, Lina, Salt Lake City, Utah.

Potter, Robert; wife, son Barry, 122 Custer Ave., Billings, Mont.

Bacon, Rodney E.; wife Alice, Santa Ana, Calif.

Bowns, Mr. and Mrs. Terry Eugene, and Jo Ann, Salt Lake City.

Plaga, Jean; Pat, Salt Lake City.

Staley, Dr. Elden D.; Barbara V., Richard E., Leland V., Jeanne, Claudia, Rock Springs, Wyo.

Weston, H.G. and Mrs. Weston, San Jose; two nephews, Stephen and Billy Conley.

Olson, Mr. and Mrs. Bernie, Kent, Wash., four children, John, Fred, Gloria and Joanne.

Vernon, Richard Lynn; Annebel, Coalville, Utah.

Blakley, Howard S.; Adline D., Cheryl L., Dale H., 810 Connie Ave., Rock Springs, Wyo.

Nomura, Dr. Frank Shimpie; Francis, Connie, Kan.

Maeda, Frank S.; Dorothy, Los Angeles.

White, Warren Bruce; wife, Frederick, Ruth Ann, Indianapolis, Ind.

Reppat, Leonard V.; wife, Topeka, Kan.

Davis, Charles; wife, Terry, Lake George, Colo.

Maxwell, Vern; wife, Steve, Kim, State Center, Iowa.

Barton, Mrs. Tom, State Center, Iowa.

Burbank, August L.; wife, Susan, Richard, Eugene, Louisa, Penelope, Melani, Brigham City, Utah.

Lavett, Tehdore Avery; wife, Salt Lake City.

Greene, Ray; wife, Steve, 2312 10th North, Billings, Mont.

Kennedy, Larry, Dayton, Ohio.

Morse, Mrs., Salt Lake City, Utah.

Jensen, Mr., Salt Lake City, Utah.

Donny, Mr. and wife, Vandalia, Ohio.

Campbell, Clark O.; wife, Ross O., Cathy Jean, Box 274, Lovell, Wyo.

Donaldson, Donald; wife, Canfield, Ohio.

Kreuger, Harold; wife, Polly, Bruce, Larry, Mary, Montello, Wis.

McDonald, John; wife, St. Anthony, Idaho.

Holtsman, I.K.; wife, Carrollton, Ohio.

Walker, Norman; wife, Rickey, Christinie, Pleasant Grove, Utah.

Kalmer, Lela, Lehi, Utah.

Rogerson, Charles, Roundup, Mont.

Thomas, David and Mrs., Nye, Mont., 3 children, David Jr., Carol and Ann.

Mr. and Mrs. Chas. T. Rogers, Roundup, Mont.

Charles, Sandra, Patty.

Grub, Calvin; wife, two children, Gen. Del., Butte, Mont.

Meyers, Henry; wife, Zella, children, 306 9th St. West, Billings, Mont.

Hoggan, Donald S.; wife, Salt Lake City, Utah.

Hamada, Minoru; wife, 2 children, Roy, Utah, also 2 other children, Dick Maeda, Los Angeles.

Danny Nomura, Roy, Utah.

Yemoto [Yamoto], Kiyoshi; wife, son, Fresno, Calif.

Sogihara, George; son.

Miller, Edward Raymond; wife, 2 children, Denver, Colo.

Owen, Lawrence Terril; wife, Dorothy, son John, Riverside, Calif.

Keith, Kenneth; wife, Harrisburg, Ill.

Vander Pluym, John; wife, 2 children, Decatur, Ill.

Donegan, Clifton and Gene [Fred and Frances], children, Vandalia, Ohio.

Good, Frederick Arnold Jr; wife Doris, 4 sons, Frederick, Robert, Alex, Jeff.,
 La Canada, Calif.

Lenz, Clyde C., Ashton, Idaho.

Sexton, Bill, son Bobby, 231 E. Granite, Butte, Mont.

Hungerford, George; wife, from Hebgen Dam and West Yellowstone.

Sewain, C. H.; wife, Long Beach, Calif.

Hayward, Charles Jr., Ted, whole family all right.

Quisnell [Quesnell], Reed A.; wife, 3 children, Arcadia, Calif.

Keuning, A.; son, La Puenete, Calif.

Christensen, Roy, Rexburg, Idaho.

Guanne, Dennis E.; wife, 2 boys, Hunter, Utah.

People Gone Through the Ennis, Mont., Hospital:

Bennett, Mrs. P.R. and son, Phillip, 16, Coeur d'Alene, Idaho.

Lost [Ost], Mrs. Ruth, New York City.

Lost [Ost], Geraldin, New York City.

Lost [Ost], Shirley, New York City.

Frederick, Paul, Elyria, Ohio.

Delhart, Carol, Colville, Wash.

Lost [Ost], Joan, New York City.

Delhart, Danny, Colville, Wash.

Lost [Ost], Larry, New York City.

Mooge [Moore], Elsie, Spokane, Wash.

Smith, Ann, Greeley, Colo.

Smith, Jo Ann, Greeley, Colo.

Whittmore [Whittemore], George, Elyria, Ohio.

(End partial evacuee list)

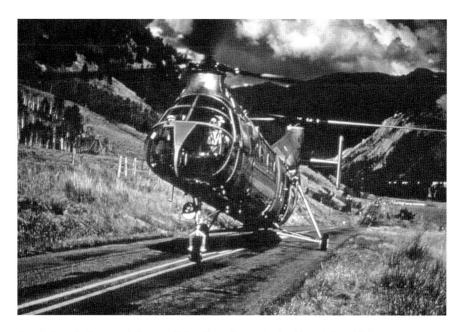

An air force helicopter delivers uninjured survivors who had lost their vehicles to the highway for transport to Virginia City. *U.S. Forest Service.*

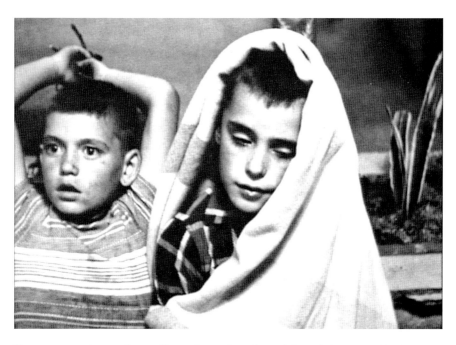

Two young survivors, exhausted but unhurt, after a long night and day trapped in the canyon. *U.S. Forest Service.*

Eugene B. and Mary Bair, care R.H. Hackson, route 2, Stone Mt., Ga.

Dave or Dale Covey, Billings.

Dean Dale, Billings.

Blue Evans (Forest Service reported him missing).

Edward T. and Elaine Egloff and children, Bruce, Rick, Mike and Steve, Denver.

Melvin and Laura Frederick and children, Melva and Paul J., Elyria, Ohio.

Thomas Goodman, Big Timber, Mont.

Johnnie Harr, Dillon, Mont.

Ray and Wilma Harrison and Bobbie, Linda and Ray, no address.

Murlin Hartkoph and family, no address.

Laurel Haun, Billings.

Jerry Lavoi, Dillon.

Mrs. Elsie Moore, Spokane, Wash.

Rev. Elmer Ost and wife, Ruth (in Sheridan, Mont., hospital) and children, Joan, Geraldine, Shirley and Larry, New York City.

Palmer Podd, Butte.

Martha Schrann, Butte.

Dick Slentz, Spokane.

Lewis and Ann Smith and daughters, Joan [Joann] and Carol, 1714 22nd Ave., Greeley, Colo.

Three children of Mr. and Mrs. E.H. Stryker, San Mateo, Calif.

Gerald and Clara Taylor, no address.

Tom Travers, Denver.

Jack and Roseva Voucher and daughter, Joan Ann, Oakview, Calif.

APPENDIX B

TECHNICAL INFORMATION ABOUT THE EARTHQUAKE

Local date and time: August 17, 1959, 11:37 p.m.
Magnitude: 7.5

Significant aftershocks:

Local date and time: August 17, 1959, 11:37 p.m.
Magnitude: 6.3

Local date and time: August 18, 1959, 12:56 a.m.
Magnitude: 6.5

Local date and time: August 18, 1959, 1:41 a.m.
Magnitude: 6

Local date and time: August 18, 1959, 4:03 a.m.
Magnitude: 5.5

Local date and time: August 18, 1959, 8:26 a.m.
Magnitude: 6.3

Local date and time: August 18, 1959, 9:04 p.m.
Magnitude: 6

Source: University of Utah Seismograph Stations, http://www.seis.utah.edu/lqthreat/nehrp_htm/1959hebg/1959he1.shtml.

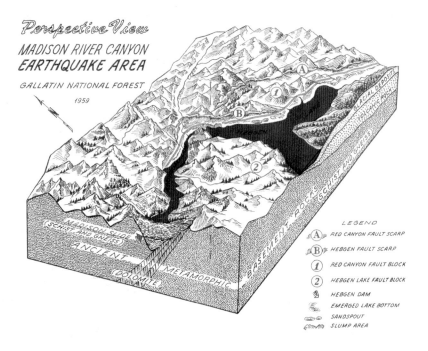

A 3D perspective helps explain the tumult caused by the shifting earth. *U.S. Forest Service.*

SUMMARY BY U.S. GEOLOGICAL SURVEY

Hebgen Lake, Montana
1959 08 18 06:37:15 UTC (local 08/17)
Magnitude 7.3
Intensity X
Largest Earthquake in Montana

This earthquake caused 28 fatalities and about $11 million in damage to highways and timber. It is characterized by extensive fault scarps, subsidence and uplift, a massive landslide, and a seiche in Hebgen Lake. A maximum MM intensity X was assigned to the fault scarps in the epicentral area. The instrumental epicenter lies within the region of surface faulting. Area of perceptibility, maximum intensity, and Richter magnitude all were larger for this earthquake than for any earlier earthquake on record in Montana (from May 1869).

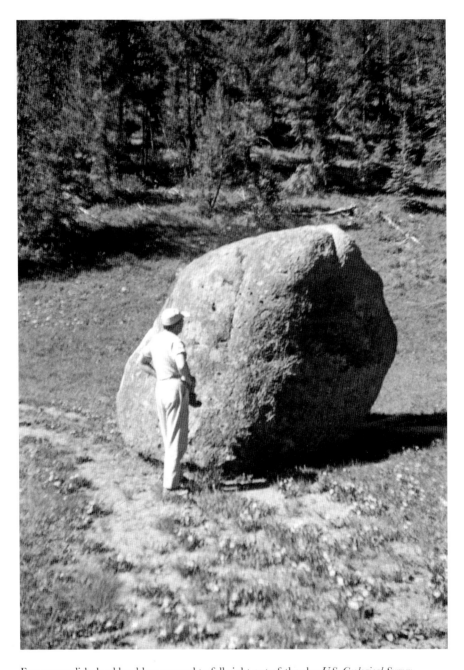

Enormous dislodged boulders seemed to fall right out of the sky. *U.S. Geological Survey*.

The most spectacular and disastrous effect of the earthquake was the huge avalanche of rock, soil and trees that cascaded from the steep south wall of the Madison River Canyon. This slide formed a barrier that blocked the gorge and stopped the flow of the Madison River and, within a few weeks, created a lake almost 53 meters deep. The volume of material that blocked the Madison River below Hebgen Dam has been estimated at 28–33 million cubic meters. Most of the 28 deaths were caused by rockslides that covered the Rock Creek public campground on the Madison River, about 9.5 kilometers below Hebgen Dam.

New fault scarps as high as 6 meters formed near Hebgen Lake. The major fault scarps formed along pre-existing normal faults northeast of Hebgen Lake. Subsidence occurred over much of an area that was about 24 kilometers north–south and about twice as long east–west. As a result of the faulting near Hebgen Lake, the bedrock beneath the lake was permanently warped, causing the lake floor to drop and generate a seiche. Maximum subsidence was 6.7 meters in Hebgen Lake Basin. About 130 square kilometers subsided more than 3 meters, and about 500 square kilometers subsided more than 0.3 meters. The earth-fill dam sustained

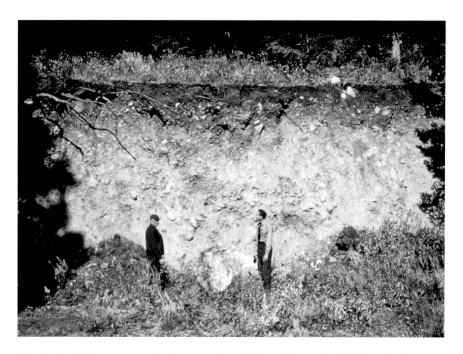

The depth of this scarp reveals the tremendous shifting of the earth. *U.S. Forest Service.*

significant cracks in its concrete core and spillway, but it continued to be an effective structure.

Many summer houses in the Hebgen Lake area were damaged: houses and cabins shifted off their foundations, chimneys fell, and pipelines broke. Most small-unit masonry structures and wooden buildings along the major fault scarps survived with little damage when subjected only to vibratory forces. Roadways were cracked and shifted extensively, and much timber was destroyed. Highway damage near Hebgen Lake was due to landslides slumping vertically and flowing laterally beneath pavements and bridges, which caused severe cracks and destruction. Three of the five reinforced bridges in the epicentral area also sustained significant damage.

High intensities were observed in the northwest section of Yellowstone National Park. Here, new geysers erupted, and massive slumping caused large cracks in the ground from which steam emitted. Many hot springs became muddy.

Source: USGS, http://earthquake.usgs.gov/earthquakes/states/events/1959_08_18.php.

THE MADISON LANDSLIDE

One of the effects of the Hebgen Lake earthquake of August 17, 1959, was to trigger a massive rockslide in the lower part of the canyon of the Madison River 6 miles below Hebgen Lake. Thirty-seven million cubic yards of broken rock slide from an area nearly half a mile long on the south side of the canyon, covering a mile of the canyon floor with debris to a maximum depth of 220 feet. The debris came very suddenly, with enough velocity to create a violent airblast, and its momentum carried the leading edge of the slide 300 vertical feet up the opposite wall of the canyon. Evidence of eyewitnesses indicates that the slide was set in motion by the first earthquake shocks at about 11:37 PM and took place in less than a minute...

The slide mass dammed the Madison River, creating a lake which rose rapidly and attained a maximum depth of 190 feet just above the slide on September 10, 3½ weeks after the slide occurred. The surface of the slide mass was extensively altered by the Corps of Engineers, US Army, in an unsuccessful attempt to control the overflow of the new lake at its maximum height. This proved impossible because the gradient of the outlet channel

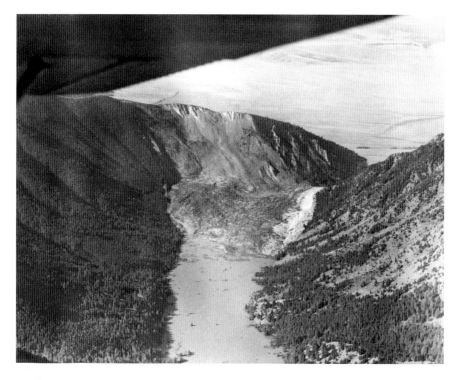

Some eyewitnesses compared the trees strewn on the slide to matchsticks that had been tossed at random. *U.S. Forest Service.*

across the slide mass was too steep and the flow too large compared to the erodability of the slide debris. The overflow rapidly eroded the lower end of the channel, and the spillway had to be cut down about 50 feet to a level where the channel appeared to be stable.

Source: Jarvis B. Hadley, "The Madison Landslide," in Billings Geological Society, 11th Annual Field Conference, September 7–10, 1960: West Yellowstone–Earthquake Area, 45–48.

NOTES

Note from the author: A number of those involved in the disaster or the rescue mentioned what time they believe certain events took place. As to be expected in a crisis of this kind, however, victims, witnesses and first-responders often experienced the passage of time in vastly different ways. As a result, their estimates about the time of a certain event often vary widely—sometimes as much as two hours. Even people making records on the scene or shortly thereafter sometimes offered contradictory statements about the sequence and timing of events. The upshot is that we cannot say for certain exactly what time the evacuation of Ennis, the rescue of Grover and Lillian Mault, the arrival of the smokejumpers and many other events actually took place. The times mentioned in the text are therefore estimates reached after comparing accounts from as many different witnesses as possible.

Chapter 1

1. DN, August 18, 1959.
2. BG, August 19, 1959.
3. Dunn, *Out of the Night*, 1–2.
4. Smith and Siegel, *Windows*, 5.
5. Psalms 121:1–6.
6. Dunn, *Out of the Night*, 11–14.
7. Bill Conley, as quoted in WT, August 17, 2009.

8. Thon, "It's a Beautiful Day" and "Terror in the Night," chaps. in *Shaken in the Night*; author interview with Carole Painter, 1990.
9. *Hebgen Lake Earthquake: A Survivor Story*; author interview with Tootie Greene, August 2015.
10. BDC, August 20, 1959; Christopherson, *Night the Mountain Fell*, 21–23.
11. E-mails from Martin Stryker to the author, 2015.

Chapter 2

12. Link, *Great Earthquake*, 11–18; MS, August 19, 1959. The Schreibers identified Hal and Polly Weston as the couple who helped them.
13. DN, August 19, 1959.
14. Matthews, "Mountains Moved," 329.
15. BG, August 16, 2009
16. SLT, August 19, 1959.
17. Christopherson, *Night the Mountain Fell*, 26.
18. BG, August 20, 1959.
19. Ibid.
20. Witkind, "Events on the Night of August 17"; MS, March 24, 1974.
21. Thon, "Terror in the Night," chap. in *Shaken in the Night*; map by Tootie Greene, courtesy Joanne Girvin, Earthquake Lake Visitor Center, U.S. Forest Service.
22. CC, August 1960; MS, August 19, 1959; Huigen, *Cataclysm*, 15–16.
23. DN, August 22, 1959; Mander, "Memories of the Earthquake"; obituary for Doug Mander, October 2006, http://www.coltrinmortuary.com/sitemaker/sites/Coltri1/memsol.cgi?user_id=125290.
24. SLT, August 19, 1959; Thon, "Terror in the Night," chap. in *Shaken in the Night*.

Chapter 3

25. MS, March 24, 1974.
26. Burley, "Earthquake," 81–82.
27. DNS, September 2, 1959.
28. BDC, August 19, 1959; DN, August 19, 1959; SLT, August 19, 1959; BDC, August 23, 1959; BDC, August 26, 1959; Link, *Great Earthquake*, 32.
29. Burley, "Earthquake," 81–82.
30. BDC, August 20, 1959; Christopherson, *Night the Mountain Fell*, 21–23.

31. Dunn, *Out of the Night*, 2.

32. E-mails from Martin Stryker to the author, 2015.

Chapter 4

33. HIR, June 15, 1955; Montana Trooper, "Montana Highway Patrol," 11; Christopherson, *Night the Mountain Fell*, 29–32; Edmund Christopherson Papers; Ancestry.com.

34. Edmund Christopherson Papers; Link, *Great Earthquake*, 65; Christopherson, *Night the Mountain Fell*, 32, 37; Ancestry.com; author interview with Glen Stevens, 1990.

35. Ball, "Report," 4.

36. Highway Maintenance Radio Log, 1–2.

37. Edmund Christopherson Papers; Link, *Great Earthquake*, 65; Christopherson, *Night the Mountain Fell*, 32, 37.

38. Highway Maintenance Radio Log, 1–2.

39. Losee, Doc, 120.

40. Edmund Christopherson Papers; Link, *Great Earthquake*, 65; Christopherson, *Night the Mountain Fell*, 37.

41. Friggins, "Earthquake," 39–40; BG, August 16, 2009; Huigen, *Cataclysm*, 15–16; 1973 letter written by Tootie Greene, copy in author's possession; author interview with Tootie Greene, August 2015.

42. HS, August 19, 1959; DN, August 19, 1959; SLT, August 20, 1959; BDC, August 20, 1959; Friggins, "Earthquake," 40; Huigen, *Cataclysm*, 15–16.

43. Friggins, "Earthquake," 39–40.

44. Thon, "Evacuation" chap. in *Shaken in the Night*; Friggins, "Earthquake," 40.

45. Mander, "Memories of the Earthquake."

46. Friggins, "Earthquake," 40; Huigen, *Cataclysm*, 5–7.

Chapter 5

47. Link, *Great Earthquake*, 62–63.

48. Elmer H. Ost to Edmund Christopherson, August 20, 1959; MS, August 19, 20, 1959; Link, *Great Earthquake*, 32–33; Christopherson, *Night the Mountain Fell*, 16–21.

49. Link, *Great Earthquake*, 31; MS, August 19, 20, 1959.

50. DP, August 17, 2009

51. Link, *Great Earthquake*, 31; MS, August 19, 20, 1959; Elmer H. Ost to Edmund Christopherson, August 20, 1959.

52. Elmer H. Ost to Edmund Christopherson, August 20, 1959.

53. Ball, "Report," 5; Link, *Great Earthquake*, 74–76.

54. Link, *Great Earthquake*, 73–74; Highway Maintenance Radio Log, 3–4.

55. BB, August 18, 1959.

56. Mander, "Memories of the Earthquake."

57. Elmer H. Ost to Edmund Christopherson, August 20, 1959.

58. Smith, *Bozeman and Gallatin Valley*, 285–86; DN, August 18, 1959.

59. Highway Maintenance Radio Log, 2.

60. "Timetable of Disaster," 3–5.

61. Bayles, "Doctor's Report"; BDC, August 21, 1959; Christopherson, *Night the Mountain Fell*, 39–41.

Chapter 6

62. E-mails from Martin Stryker to the author, 2015; Edmund Christopherson Papers; Link, *Great Earthquake*, 65–66; Christopherson, *Night the Mountain Fell*, 32–34; author interview with Glen Stevens, 1990.

63. Dunn, *Out of the Night*, 3–4; Edmund Christopherson Papers; Link, *Great Earthquake*, 66–70; Christopherson, *Night the Mountain Fell*, 34–36; Losee, *Doc*, 120–21; author interview with Glen Stevens, 1990; Huigen, *Cataclysm*, 29.

64. Burley, "Earthquake," 82; BDC, August 20, 1959; "Quake That Rocked Vacationland," 24; MS, March 24, 1974; Friggins, "Earthquake," 40.

Chapter 7

65. Summary by Madison District Ranger; Tebbe, *Hebgen Lake Earthquake*, ii–12.

66. "Fred Gerlach, Helicopter Pilot," 7–8; SR, August 3, 1959; Link, *Great Earthquake*, 85–86.

67. BDC, August 21, 1959.

68. Ibid.; Bayles, "Doctor's Report," 79–80; Friggens, "Earthquake," 57.

69. BG, August 19, 1959.

70. Nicol, "Jumper Recounts Quake Rescue," 10–11; Charles Nyquist interview, Smokejumpers Oral History Project; Mander, "Memories

of the Earthquake"; Friggins, "Earthquake," 57; Tebbe, *Hebgen Lake Earthquake*, ii–2; Thon, "Help Has Arrived," chap. in *Shaken in the Night*.

71. Mander, "Memories of the Earthquake."

72. Nicol, "Jumper Recounts Quake Rescue," 11.

73. BG, August 19, 1959; MS, August 23, 1959.

74. American National Red Cross, Report and Correspondence; BDC, August 18 and August 19, 1959.

75. BDC, August 20, 1959.

76. SLT, August 20, 1959; Ray Painter obituary, DN, March 17, 1996; Tebbe, *Hebgen Lake Earthquake*, ii–1; Link, *Great Earthquake*, 84.

Chapter 8

77. SLT, August 18, 1959.

78. Bayles, "Doctor's Report," 79–80; DN, August 19, 1959; Thon, "SOS," chap. in *Shaken in the Night*.

79. BDC, August 21, 1959.

80. Ibid., August 20 and August 21, 1959.

81. MS, August 19, 1959.

82. Elmer H. Ost to Edmund Christopherson, August 20, 1959.

83. GDT, August 20, 1959; DP, August 17, 2009; Link, *Great Earthquake*, 31; MS, August 19, 1959; Witkind, "Events on August 17."

84. Elmer H. Ost to Edmund Christopherson, August 20, 1959.

85. Mander, "Memories of the Earthquake"; Tebbe, *Hebgen Lake Earthquake*, ii–4.

Chapter 9

86. DM, August 18, 1959.

87. "Quake That Rocked Vacationland," 23; Conley, "Reminiscence"; SLT, August 20, 1959.

88. Ancestry.com; SLT, August 20, 1959

89. PR, August 24 and August 31, 1959.

90. Findagrave.com; BDC, August 19, 1959; Christopherson, *Night the Mountain Fell*, 9.

91. Ancestry.com; Huigen, *Cataclysm*, 7; Findagrave.com; BG, August 19 and August 28, 1959.

92. 1973 letter written by Tootie Greene, copy in author's possession.

93. Thon, "Rescue," chap. in *Shaken in the Night*.

94. Christopherson, *Night the Mountain Fell*, 9.

95. SLT, August 20, 1959.

96. E-mails from Martin Stryker to the author, 2015.

97. Dunn, *Out of the Night*, 16, 35.

Chapter 10

98. Conley, "Reminiscence"; Huigen, *Cataclysm*, 6.

99. DN, August 21, 1959.

100. Ibid.; Ancestry.com.

101. DN, August 20–August 25, 1959; SLT, August 20 and 21, 1959.

102. PR, August 24 and August 31, 1959.

103. BG, August 19 and August 21, 1959.

104. DIL, August 25 and August 27, 1959.

105. ISJ, August 25, 1959.

106. BDC, August 23, 1959.

107. BDC, August 24, 1959.

108. Ibid., August 27, 1959.

109. ISJ, August 26, 1959.

110. BG, August 27, 1959.

111. PR, September 1, 1959. See Thon, *Twenty-Eight*, for fascinating and well-researched information on all those who died from earthquake injuries or were lost in the slide.

112. MS, August 21, 2000.

Epilogue

113. WYN, September 5, 2014

114. Church History Library, Church of Jesus Christ of Latter-Day Saints, Salt Lake City, Utah.

115. E-mails from Martin Stryker to the author, 2015.

116. Author interviews with Dan Donegan and Tootie Greene, 2015; Ancestry.com.

117. CC, September 1960.

118. Ancestry.com.

119. Ibid.

120. Coltrin Mortuary, http://www.memorialsolutions.com/sitemaker/sites/Coltri1/memsol.cgi?user_id=125290.

121. Ancestry.com.

122. Ibid.

123. National Smokejumper Association, http://smokejumpers.com/index.php; BDC, August 19, 1999.

124. Author interviews with Joanne Girvin, John Owen and Bill Conley, 2105; BG, August 16, 2009.

125. Ancestry.com.

126. DN, March 17, 1996; WYN, September 5, 2014; Thon, "50th Anniversary of the Earthquake," chap. in *Shaken in the Night*.

127. BG, August 16, 2009; e-mails from Martin Stryker to the author, 2015

128. Dunn, *Out of the Night*, 120.

129. Author interview with Tootie Greene, 2015; Ancestry.com; BG, August 16, 2009; Huigen, *Cataclysm*, 17.

BIBLIOGRAPHY

Manuscript Sources and Archives

Gallatin History Museum, Bozeman, Montana.
Mansfield Library Archives and Special Collections, University of Montana, Missoula.
Montana Historical Society, Helena.
Utah Historical Society, Salt Lake City.
Yellowstone National Park Archives, Gardiner, Montana.

Books

Ball, Verla. *Montana Earthquake at Hebgen Lake*. N.p., 1960.
Billings Geological Society. *11th Annual Field Conference, September 7–10, 1960: West Yellowstone–Earthquake Area*. Billings, MT: Billings Geological Society, 1960.
Christopherson, Edmund. *The Night the Mountain Fell: The Story of the Montana-Yellowstone Earthquake*. West Yellowstone, MT: Yellowstone Publications, 1962.
Dunn, Irene Bennett. *Out of the Night: A Story of Tragedy and Hope from a Survivor of the 1959 Montana-Yellowstone Earthquake*. Sandpoint, ID: Plaudit Press, 1998.

Huigen, Douglas W. *Cataclysm: When Human Stories Meet Earth's Faults.* Spokane, WA: Skifoot Press, 2009.

Link, L.W. *The Great Montana Earthquake.* Cardwell, MT, 1964.

Losee, R.E. *Doc: Then and Now with a Montana Physician.* Guilford, CT: Lyons Press, 1994.

Smith, Phyllis. *Bozeman and the Gallatin Valley: A History.* Guilford, CT: Twodot, 2002.

Smith, Robert B., and Lee J. Siegel. *Windows into the Earth: The Geologic Story of Yellowstone and Grand Teton National Parks.* New York: Oxford University Press, 2000.

Thon, Anita Painter. *Shaken in the Night: A Survivor's Story from the Yellowstone Earthquake of 1959.* N.p.: CreateSpace Independent Publishing Platform, 2014.

————. *The Twenty-Eight: Living with the Aftershocks; Stories from Survivors and Family Members of Those Who Perished in the 1959 Yellowstone Earthquake.* N.p.: CreateSpace Independent Publishing Platform, 2015.

Articles and Documents

American National Red Cross. Reports and Correspondence Related to 1959 Montana Earthquake. National Archives.

American National Red Cross, Pacific Area. Article on Montana Earthquake. Christopherson Papers.

Ball, R.M. "A Report: Earthquake! August 17, 1959." Montana Power Company.

Barkley, Sue. "The Madison Canyon Earthquake—1959: Some Nurses' Recollections." *In Celebration of Our Past.* Gallatin County Historical Society, 1989.

Bayles, R.G. "A Doctor's Report." Billings Geological Society, *11th Annual Field Conference*, 78–80.

Burley, Robert M. "Earthquake." Billings Geological Society, *11th Annual Field Conference*, 81–82.

Conley, Bill. "Reminiscence of Earthquake." 2015, copy in author's possession.

"Disasters: Death on the Madison." *Time*, August 31, 1959.

Edmund Christopherson Papers, 1903–74. Mansfield Library Archives and Special Collections.

"Fred Gerlach, Helicopter Pilot." *Static Line*, National Smokejumpers Association, April 1998, 7–9.

Friggins, Paul. "I Only Did What I Could." *Reader's Digest*, March 1960.

———. "Night of the Earthquake." *Christian Herald*, March 1960.

"The Great Quake That Rocked Vacationland." *Life*, August 31, 1959.

Hancock, L. Scott. "We Were There." *River Journal* 18, no. 8 (2009).

Highway Maintenance Radio Log. Station KOA 555, Bozeman, August 18, 1959. Montana Historical Society.

Interview of Charles Nyquist for the Smokejumpers Oral History Project, OH 133-78. Mansfield Library Archives and Special Collections.

Mander, Florence B. "Memories of the Hebgen Lake Earthquake." Typescript courtesy of Tootie Greene; also self-published as a pamphlet in 1959.

Matthews, Samuel W. "The Night the Mountains Moved." *National Geographic* 117, no. 3 (1960).

"Montana's Earthquake: Chaos to Normalcy in Three Weeks." *Majestic Montana*, Fall–Winter 1959.

Montana Trooper. "Montana Highway Patrol Celebrates 75 Years of Service, 1935–2010," January 25, 2010.

Motherspaugh, Kelly. "Earthshaking Events in Yellowstone." *National Parks Magazine* 33, no. 146 (1959).

Nicol, Bob. "Jumper Recounts Yellowstone Quake Rescue." *Smokejumper Quarterly Magazine*, April 2000: 10–12.

O'Reilly, John. "Eyewitness to an Act of God." *Sports Illustrated*, November 2, 1959.

Russell, John C. "'A Funny Feeling': Remembering the 1959 Hebgen Lake Earthquake." *Pioneer Museum Quarterly*, Summer 2009.

Summary by Madison district ranger Neil Howarth. "Action at Ennis— Tuesday, August 18, 1959." Christopherson Papers.

Tebbe, Chas. L. *Hebgen Lake–Madison River Earthquake Disaster, August 1959, Gallatin-Beaverhead National Forests*. U.S. Forest Service Report.

"Timetable of Disaster." *Monitor*, October 1959, 2–7.

Welsch, Jeff. "Eight Seconds That Changed Everything." *Montana Quarterly*, Fall 2009.

Witkind, Irving J. "Events on the Night of August 17, 1959—The Human Story." Published by the U.S. Geological Survey as Professional Paper 435-A, 1964.

Newspapers

Bend Bulletin (BB), Bend, Oregon
Billings Gazette (BG), Billings, Montana
Bozeman Daily Chronicle (BDC), Bozeman, Montana
Circleville Herald (CH), Circleville, Ohio
Crossroads Chronicle (CC), Vandalia, Ohio
Daily Inter Lake (DIL), Kalispell, Montana
Daily Messenger (DM), Canandaigua, New York
Daily News (DNS), Dayton, Ohio
Denver Post (DP), Denver, Colorado
Deseret News (DN), Salt Lake City, Utah
Great Falls Tribune (GFT), Great Falls, Montana
Greeley Daily Tribune (GDT), Greeeley, Colorado
Helena Independent Record (HIR), Helena, Montana
Humboldt Standard (HS), Eureka, California
Idaho State Journal (ISJ), Pocatello, Idaho
Independent (I), Long Beach, California
Missoulian (M), Missoula, Montana
Montana Standard (MS), Butte, Montana
Post Register (PR), Idaho Falls, Idaho
Salt Lake Tribune (SLT), Salt Lake City, Utah
Spokesman Review (SR), Spokane, Washington
Washington Times (WT), Washington, D.C.
West Yellowstone News (WYN), West Yellowstone, Montana

DVDs

*The 50th Anniversary of the Hebgen Lake Earthquake.*U.S. Forest Service, 2001.
*A Force of Nature: Hebgen Lake Earthquake.*U.S. Forest Service, 2001.
*Hebgen Lake Earthquake: A Survivor Story.*U.S. Forest Service, 2001.
Yellowstone Earthquake: The Story of the 1959 Hebgen Lake Disaster. Yellowstone
 Publications, 1997.

WEBSITES

Ancestry.com. http://home.ancestry.com.

Coltrin Mortuary. http://www.coltrinmortuary.com.

National Archives. http://www.archives.gov.

University of Utah Seismograph Stations. http://www.seis.utah.edu/lqthreat/nehrp_htm/1959hebg/1959he1.shtml.

USDA Forest Service. http://www.fs.fed.us.

U.S. Geological Survey. http://www.usgs.gov.

INDEX

ABOUT THE AUTHOR

L arry E. Morris is an independent writer and historian. He was born and raised in Idaho Falls, Idaho, and received a master's degree in American literature and a bachelor's degree in philosophy, both from Brigham Young University. He has completed extensive research on the members of the Lewis and Clark Expedition and is the author of *The Fate of the Corps: What Became of the Lewis and Clark Explorers After the Expedition* (Yale University Press), named a Top Academic Title by *Choice*. He is also the coauthor (with Ronald M. Anglin) of *The Mystery of John Colter: The Man Who Discovered Yellowstone* (Rowman & Littlefield). He has published articles on expedition members in *We Proceeded On*, *American History* and *St. Louis Magazine*. He has spoken on Lewis and Clark at the national meeting of the Lewis and Clark Trail Heritage Foundation; the Montana Book Festival; the Salt Lake City Book Festival; bicentennial events in Washington, Oregon and Montana; a meeting of the Charles Redd Center for Western Studies; and a meeting of the Montana Historical Society.

Morris is the author of *The Perilous West: Seven Amazing Explorers and the Founding of the Oregon Trail* (Rowman & Littlefield) and has also published articles on the early American fur trade in the *Missouri Historical Review*, the

Rocky Mountain Fur Trade Journal and the proceedings of the 2010 and 2012 fur trade symposiums. He is a contributor to the *Oregon Encyclopedia* (http://www.oregonencyclopedia.org). He has spoken on related topics at Three Forks, Montana, and Pinedale, Wyoming.

Larry Morris is also quite interested in Mormon history and was an editor with the Joseph Smith Papers Project. He is the coeditor (with John W. Welch) of *Oliver Cowdery: Scribe, Elder, Witness* (Neal A. Maxwell Institute for Religious Scholarship) and has published related articles in *BYU Studies*, *Journal of Mormon History*, *Journal of Book of Mormon Studies*, *FARMS Review of Books*, *Ensign* and *New Era*. He has also published three books on Mormon history with Deseret Book, including *A Treasury of Latter-Day Saint Letters*. He has spoken at a meeting of the J. Reuben Clark Law Society, BYU Education Week and the annual conference of the John Whitmer Historical Association.

Larry and his wife, Deborah, have four children and seven grandchildren and live in Salt Lake City, Utah.

ABOUT THE FOREWORD AUTHOR

Lee Whittlesey is park historian for the National Park Service at Yellowstone National Park. He has a master's degree in history from Montana State University and a juris doctorate from the University of Oklahoma. In recognition of his extensive writings and contributions to Yellowstone National Park, Idaho State University conferred upon him an honorary doctorate of science and humane letters in 2001. Since 1996, he has been an adjunct professor of history at Montana State University and was awarded an honorary PhD in history by MSU in 2014.

Lee Whittlesey's forty-year studies in the history of the Yellowstone region have made him an expert on Yellowstone's vast literature and have resulted in numerous publications. He is the author, coauthor or editor of eleven books and more than twenty-five journal articles. A twenty-five-year project with Dr. Paul Schullery, "The History of Mammals in the Greater Yellowstone Ecosystem, 1796–1881: An Interdisciplinary Analysis of Thousands of Historical Observations" is forthcoming as a full book in 2016. "'This Modern Saratoga of the Wilderness!': A History of Mammoth Hot Springs and the Village of Mammoth in Yellowstone National Park" is awaiting publication by the National Park Service.

Whittlesey also published *The Guide to Yellowstone Waterfalls and Their Discovery* (2000), in which he and two coauthors revealed to the world for the first time the existence of more than three hundred previously unknown waterfalls in Yellowstone National Park. For this accomplishment, he was featured on ABC News, NBC News, the Discovery Channel and the Travel Channel, as well as in *People* magazine. He appeared in Ken Burns's five-part special on national parks, the Arun Chaudhary film shot for President Obama's White House, the British Broadcasting Corporation's hour-long program entitled *Unnatural Histories—Yellowstone* and, most recently, on Montana PBS's history of Yellowstone. He is often seen on regional and local television talking about Yellowstone's history. His credits include *Gateway to Yellowstone: The Raucous Town of Cinnabar on the Montana Frontier* (2015); *Ho! for Wonderland: Travelers Accounts of Yellowstone, 1872–1914* (with Elizabeth Watry, 2009); *Images of America: Yellowstone National Park* (with Elizabeth Watry, 2008); *Images of America: Fort Yellowstone* (with Elizabeth Watry, 2008); *Storytelling in Yellowstone: Horse and Buggy Tour Guides* (2007); *Yellowstone Place Names* (2006); *Myth and History in the Creation of Yellowstone National Park* (with Dr. Paul Schullery, 2003); *A Yellowstone Album: Photographic Celebration of the First National Park* (1997); *Death in Yellowstone* (1995); *Lost in the Yellowstone* (with Truman Everts, 1995); and the voluminous *Wonderland Nomenclature* (1988).